Near Andersonville

THE NATHAN I. HUGGINS LECTURES

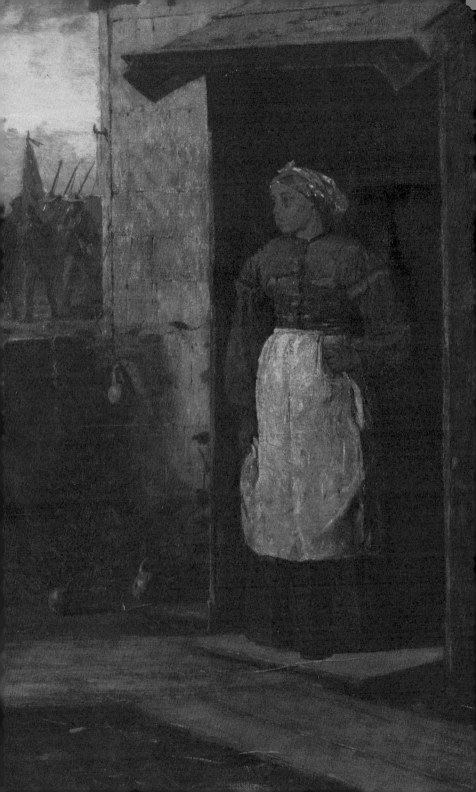

Near Andersonville

Winslow Homer's Civil War

Peter H. Wood

Harvard University Press

CAMBRIDGE, MASSACHUSETTS, AND LONDON, ENGLAND

2010

Book designed by Dean Bornstein

Frontispiece: Winslow Homer, *Near Andersonville,* 1865–1866. Collection of the Newark Museum. For full credit see plate 1.

Library of Congress Cataloging-in-Publication Data

Wood, Peter H., 1943–
Near Andersonville : Winslow Homer's Civil War / Peter H. Wood.
p. cm.–(The Nathan I. Huggins lectures)
Includes bibliographical references and index.
ISBN 978-0-674-05320-5 (alk. paper)
1. Homer, Winslow, 1836–1910. Near Andersonville. 2. African
Americans in art. 3. United States–History–Civil War,
1861–1865–Art and the war. I. Title.
ND237.H7A73 2010
759.13–dc22 2010014767

*For Julius Scott, Karen Dalton, and Brooke Hopkins—
impressive humanists and kind companions who
have strengthened me with their friendship,
broadened me with their insights,
and inspired me through their lives*

CONTENTS

COLOR PLATES

FIGURES

All illustrations are by Winslow Homer unless otherwise noted.
HW = *Harper's Weekly*

Man is the only picture-making animal in the world.
He alone of all the inhabitants of earth
has the capacity and passion for pictures.

—Frederick Douglass, "Pictures," c. late 1864

INTRODUCTION

This book focuses on one of the least known paintings of the great American artist Winslow Homer. Though he completed the picture in 1866, it was lost from public view for a century, and its true title, *Near Andersonville,* was not discovered until 1987. I have been interested in American race relations and in the artistry of Winslow Homer for most of my life, so this image has intrigued me ever since I first encountered it three decades ago. The invitation to deliver the Nathan I. Huggins Lectures at Harvard provided me with a perfect chance to delve into the strange history, surprising content, and rich context of this long-neglected work. I jumped at the opportunity.

The timing seems right. Symbolically, 2010 marks the centennial of Homer's death and the sesquicentennial of Abraham Lincoln's election; another important national commemoration of the Civil War is beginning to unfold. I come away from this exploration with a heightened sense that Homer's unique painting is more remarkable than most scholars have realized. I hope that drawing *Near Andersonville* into the light will prompt others to view the artist's career from a fresh perspective and to think in new ways about key portions of the unfathomable saga that was the American Civil War.

In this three-part book, I use Chapter 1, "The Picture in the Attic," to address a number of questions about the painting itself. How was a work unknown to Homer experts finally brought to light in the 1960s? How could Winslow Homer, the white New England artist, even have conceived such a painting in the first place? And why have we never known, until now, the specific

identity of the original owner when the picture was sold, for the first and only time, a year after the end of the Civil War? Having looked at aspects of the painting's own past, I then turn to the tumultuous history hidden, but hinted, within the painting. We begin with the exciting discovery, in the late 1980s, of the picture's original title, at the time of its sale in 1866. The fact that Homer called his creation *Near Andersonville* obliges us to revisit Andersonville itself, the notorious wartime prison that became a contested and enduring cultural symbol. That, in turn, prompts a closer look at Homer's war experiences and at other key images of blacks that he generated during the war years. In many of them, he takes his viewers "behind enemy lines." Hence the title for Chapter 2, which ends with a consideration of Union General George Stoneman's little-known cavalry raid below Atlanta in July 1864, the desperate fiasco that gave rise to this painting.

The final chapter focuses at last on the enslaved figure who stands so stoically in the foreground of the painting. "The Woman in the Sunlight" offers an assessment of the individual and her gaze, the dark doorway in which she is framed, and the crude planks that stretch out in front of her. I suggest emblematic meanings for the cloth that wraps her head and the gourds that grow along the fence beside her. This chapter explores what it meant for Homer's generation that she stands on an obvious threshold, and it relates her situation to that of the Egyptian servant Hagar in the Book of Genesis. I conclude by considering the picture's ongoing relevance in the twenty-first century. Much has changed since the painting reemerged half a century ago. At last all of us—American historians, art scholars, and the public at large—are finally in a position to appreciate more fully this remarkable woman.

CHAPTER I

THE PICTURE IN THE ATTIC

The Painting Finds a Home in Newark
Ever heard of a man named Homer?

Horace Kellogg Corbin died on February 5, 1960, at his estate in Llewellyn Park, a wealthy enclave eight miles west of Newark and a dozen miles from Manhattan. This leading citizen of New Jersey, age 72, had served as president of the state's largest bank, director of New Jersey's Chamber of Commerce, and vice-chair of the New York Port Authority. A prominent civic leader, Corbin had belonged to the Bay Head Yacht Club, the Baltusrol Golf Club, and the Princeton Board of Trustees.[1]

After the funeral, the banker's grown children gathered at the "Big House," as they called it, to sort through their parents' belongings. The five Corbins and their spouses found more than their households could absorb. Their late mother was descended from Richard Stockton, a signer of the Declaration of Independence, and she had owned numerous heirlooms. There was also much from their father's side, including expensive pictures that "were business gifts from Elmer Bobst," a wealthy executive, philanthropist, and Republican donor. One Corbin son conceded he did not "know whether the paintings are any good or not."[2]

Once the three Corbin brothers and two sisters had made their selections, they agreed that Clementine (the oldest daughter) would dispose of the odds and ends that still cluttered the attic. When she asked Mr. Blauvelt from the Lincoln Storage Warehouse to look over the remaining bric-a-brac, he said

he would haul it all away for fifty dollars.[3] Horace Kellogg Corbin III, a son of Horace Jr. and a grandson of the deceased, was a senior at Andover at the time. Known as Terry, he recalled that his Aunt Clementine became suspicious when Mr. Blauvelt called her back once too often, insistent to get the job done. Worried that something was amiss, Clementine summoned her siblings and their spouses for one further search. Later, in a lively essay for his college Fine Arts class, Terry recounted what happened next:

> The following evening the five . . . couples gathered at the "Big House" and began a careful inspection of each photograph, painting, and piece of china. After a good hour of searching, the oldest son . . . called out to the others, "Ever heard of a man named Homer?" After a moment of reflection his wife suggested, "Winslow Homer?" A medium size painting . . . bearing the simple signature "Homer 1866" was taken from the attic. The search was over.[4]

In the nick of time, the Corbins had solved the riddle of the warehouse man's keen interest (Plate 1). For now, the picture was safe, but the Corbins were uncertain what to do next. Horace Jr. took the painting home until they could learn more. Terry recalled that the "dark picture remained untouched" in his father's second-floor study for many months.[5] An aunt even suggested selling it for $300.[6]

Finally, after nearly two years, a break came when Robert Corbin went fishing with his friend Lindley Eberstadt. Lin, as he was called, worked at the center of the New York art world. With his brother Charles, he ran Edward Eberstadt & Sons, the family's Madison Avenue establishment trading in rare Americana and specializing in Civil War materials.[7] So at Bob's

first mention of Winslow Homer, Lin leapt like a trout rising for a fly. It was "shortly before midnight one evening," Terry recounted, when Uncle Bob "came bounding in from a fishing trip with his friend" and raced upstairs. "After an hour of careful inspection and subtle joking," Eberstadt announced that "in his mind there was little doubt" the item was genuine, "but that he wished to reserve final judgment until he could have a further study made in New York."[8]

The dealer took the picture with him, after scribbling out a receipt. "*Received . . . one painting of colored woman in doorway . . . signed 'Homer 1866'.*" He gave the dimensions as "*18 × 22,*" and he estimated the value at $20,000.[9] Eberstadt knew the picture's market price would rise with a full provenance, so he urged the siblings to explore when the picture had come into the family. Was it among the business gifts from Elmer Holmes Bobst, the conservative millionaire who had put Mr. Corbin on the board of Mr. Bobst's huge pharmaceutical firm, Hoffman-LaRoche? Or was it something else entirely? For answers, the family turned to Clement Corbin, the older brother of the man who had passed away two years earlier.

Uncle Clement, born in 1880, soon came through with a surprise. On February 7, 1962, he found an old photograph, taken in 1884 (Figure 1). It showed the dining room of the Kellogg family residence at 667 Newark Avenue in Elizabeth, New Jersey, as it had appeared when he was a small boy. At 82, he still remembered that Homer's picture had hung to the right of his grandmother's sideboard, and he drew an emphatic arrow on the photograph to show its location. Clement recalled hearing older relatives say the painting "had been in the family . . . for . . . 15 years or more at the time this photo was taken."[10]

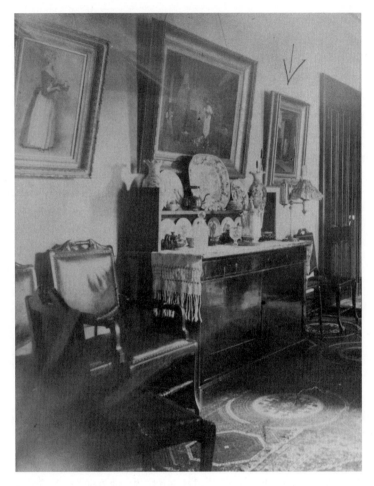

FIGURE I. Dining Room of the Kellogg Home, c. 1884 (Detail). Collection of the Newark Museum.

That evening, Bob Corbin and Lin Eberstadt had a conversation regarding the picture's history. "Don't like to keep pestering you," Lin wrote his friend the next day, "but I think a statement

of provenance and title would be a good thing to have at this point." He enclosed a summary of "what I got out of our talk," and he asked family members to correct anything that seemed "balled up."[11] A week later the art dealer received the revised provenance. The Corbins enclosed their uncle's old photograph and his recollections, and they attested vaguely that the picture was linked to their ancestor, Elijah Kellogg. The siblings knew that Elijah Kellogg (born in Norwalk, Connecticut, in 1784) had died in 1856. They believed the Homer painting, completed a decade later, had "been in the family . . . for about 15 years or more" in 1884. In their signed statement, they attested that the painting had belonged to Elijah's second wife, Martha Crane Kellogg. Then the picture descended to her youngest daughter, Clementine Kellogg Corbin. When she died in 1929, her son Horace inherited the picture, and when he died in 1960, it passed to his five children.[12]

Eberstadt now had a chain of ownership that was nearly complete, missing only an initial link to the artist. Meanwhile, he had noticed an earlier signature and date, "Homer '65" in the painting's lower left corner. Homer often worked on pictures for extended periods; he had been known to put several dates on a canvas. But for the dealer, this 1865 date meant the object could now legitimately be called a "Civil War painting" in timing as well as subject matter. He made up a brochure, with an eye toward interesting a high-end purchaser, and he raised the picture's estimated value to $45,000.[13] With the family's approval, Eberstadt also gave the painting a name. He called it *Captured Liberators,* a reference to the background scene where Confederates, flag aloft, escort unarmed Union soldiers dressed in blue.

After years in an attic, the picture needed more than a title, for it "was in extremely frail condition."[14] The canvas had been poorly "cleaned" at some point and perhaps even varnished; "a few cracks and chips" called for inspection and maintenance.[15] So in April, Eberstadt paid $100 for frame repair and a slight cleaning. In addition, the dealer sought out top-flight authentication. Initially, he approached Albert Ten Eyck Gardner of the Metropolitan Museum of Art, who had published a study of Homer the previous year. But word came back that "unfortunately Mr. Gardner does not issue certificates."[16]

Next, Eberstadt turned to Lloyd Goodrich, the respected Homer scholar at the Whitney Museum of American Art. Goodrich expressed interest, but he was busy, and dealing with him could be trying.[17] Eventually, after examining the painting repeatedly, he declared the work "entirely characteristic of Winslow Homer in subject, style, color, drawing, and brushwork."[18] But he took six months to complete his brief report. "Ought to tell you," Eberstadt fumed to Bob Corbin, "I haven't absconded with the Homer but have been having one hell of a time with Goodrich. . . . Nothing to be done until he comes through."[19]

But there *was* something to be done: look for a private buyer; and it made sense to begin at the top. Paul Mellon's fortune made him one of the wealthiest men in America, and he and his wife were noted art collectors. In July 1962, Eberstadt sent a two-sentence note to Robert Corbin. "Dear Bob: Mr. Mellon has asked me to bring the Homer to Washington and I am leaving tomorrow. Here's hoping he likes it."[20] But the Mellons decided not to purchase the painting. Instead, they soon added a very different Homer woman to their collection, the stylish and genteel lady depicted in *Autumn* (1877).

After that, the Corbins' picture did not move much.[21] The only public display involved an exhibition at Bowdoin College in Maine, not far from Prout's Neck, the spot where Homer lived and worked from 1884 until his death in 1910. In 1964, Bowdoin's museum mounted a pioneering exhibit of black images in American art, and the show included *Captured Liberators*.[22] But still no buyer came forward. "I have a suspicion," Terry Corbin had told his college professor in 1962, that the picture "will remain in the family for several years before they pass it on to an art museum."[23]

The donation came in 1966.[24] In December the Newark Museum announced acquisition of an "almost forgotten painting by Winslow Homer" containing "a young Negro girl."[25] Woman or girl, she had found a new home, and given Homer's high standing we might expect a flurry of scholarly interest and evaluation. But rising social tensions, plus inertia in the nation's cultural and intellectual power structure, made that impossible. Few experts had the inclination or background to make sense of this troublesome picture.

The late sixties was hardly the best time to address the challenges posed by *Captured Liberators*. First of all, Newark itself simmered with racial discontent. In July 1967, after the arrest and beating of a black cab driver by two white policemen, "the most devastating riots in the history of New Jersey" erupted only blocks away from the Newark Museum. After five days of unrest, twenty-six people had been killed.[26] A week later, police violence in Detroit sparked a similar five-day urban rebellion that cost forty-three lives. Americans were preoccupied with current events, and racial passions remained deeply inflamed.

Among historians, the hard work of reexamining the nation's history through a wider lens was only just beginning.

The lily-white Civil War Centennial had recently concluded, and explorations of the black role in that conflict were still in their infancy. It had been less than three decades since Hollywood produced *Gone with the Wind* (1939), and two more decades would pass before black Union soldiers appeared in *Glory!* (1989). Moreover, in the cloistered world of American art scholars, few had ever seriously studied images of blacks. One exception was Alain Locke, North America's first black Rhodes Scholar, but his 1940 survey, *The Negro in Art*, was not reprinted until 1969.[27] Meanwhile, experts on Homer knew he had depicted blacks, as in *The Gulf Stream* and *After the Hurricane* (both from 1899). But they often avoided the challenging subject matter to dwell instead on his brush strokes or use of color.[28] Except for the artist's numerous African-American admirers, his loyal followers generally ignored such works. They preferred the painter's many less-troubling and more accessible pictures that were being reproduced by the thousands.

Homer's public reputation rested on his robust hunting and fishing images and his rural scenes of innocent adolescents. The versatile artist was also revered for his graphics in *Harper's Weekly*, his iconic Civil War illustrations, his stunning watercolors, and his scenes of women at the beach or playing croquet. Above all, he was known for his incomparable coastal pictures and seascapes, his paintings of ships and sailors, and the ocean in all its moods. This towering reputation—plus the unsettled times, limited Civil War scholarship, and indifference to black images in the world of fine arts—all worked against making sense of *Captured Liberators*. The picture had found a public home in 1966, but it remained hidden from the light.

The Artist Comes of Age in Cambridge
The symbol of the North is the pen. . . .

By 1966, when the Newark Museum received *Captured Liberators* as a gift, the general outlines of Homer's early life had been well known for years. He was born into a middle-class Boston family in 1836 and raised by a blustery father and a sensitive mother who was an excellent watercolorist. Reared in Cambridge, Winslow served a frustrating apprenticeship in the Boston lithography firm of J. H. Bufford from 1855 to 1857. He then became a freelance artist with ties to the new *Harper's Weekly.*

But scholars in the 1960s understood little about the antislavery world in which Homer grew up.[29] Books were just appearing that redeemed New England's abolition movement from decades of mainstream ridicule and neglect.[30] The current landscape is different, for a rich literature on race relations in antebellum Boston finally gives us a better sense of the wider racial context in which Homer came of age. This provides a key new dimension in understanding what swirled around this sensitive boy during his formative years. We can now see things in the artist's initial decades that offer clues as to why he might have painted the Newark picture.

We know that in the late 1820s Charles Homer, a Boston hardware merchant, attended Lyman Beecher's Hanover Street Church. (Charles would have met the next generation of Beechers, including Henry Ward and Harriet, a young woman nearly his own age.) When the Hanover Street Church burned down, Homer followed Reverend Beecher to his new Bowdoin Street Church, until the illustrious minister left for the West in

1832. The next year, Charles married Henrietta Benson from Cambridge.

The Homers began a family in Boston, shifting to "the rural village of Cambridge" in 1842 when Winslow, their second son, was six.[31] "When we moved to Cambridge," Winslow's older brother Charles recalled, "the idea was to give us boys an education, but I was the only one who wiggled through Harvard College. Win wanted to draw."[32] The family lived in three Cambridge homes before moving to Belmont in 1858. From 1849 to 1854, the Homers (plus a young Irish servant) occupied a house on Garden Street facing the Cambridge Common, near Harvard Square.[33] From the front steps Winslow could see Harvard Yard and the famous elm tree where Washington had taken command of the American army in 1775.

Like neighboring Boston, Cambridge had racial tensions, obvious to an alert child. Thomas Wentworth Higginson, born there in 1823, remembered white unwillingness to accept the full "humanity" of African Americans. The famous abolitionist explained that "law and custom . . . forbade any merchant or . . . mechanic to take a colored apprentice," and every "common carrier . . . was expected to eject from his conveyance any negro on complaint of any white passenger." An instance "occurred in Cambridge in my childhood," he recalled, "within sight of the Washington Elm." Moreover, local churches "still had negro pews, these being sometimes boarded up in front, so that the occupants could only look out through peep-holes."[34]

Mary Walker, an ex-slave from North Carolina who lived near the Homers, took part in debates over segregated seating at the Old Cambridge Baptist Church in the 1850s.[35] But by mid-century, many whites in Cambridge had abolitionist leanings, and Walker became part of the town's growing community of

fugitive slaves.[36] Lewis G. Clarke and John Milton Clarke, for example, were light-skinned brothers who had escaped from Kentucky in 1842. Reaching Cambridge the next year, they lived in the home of Aaron Stafford and his wife Mary, a sister of Harriet Beecher Stowe. With other ex-slaves, the Clarke brothers attended the antislavery church of Reverend Joseph C. Lovejoy, and in 1846, Lovejoy published a narrative dictated by the Clarke brothers.[37]

The Homers could hardly have avoided local controversies over segregation and slavery. In 1850, they surely heard about the dispute that led to the removal of a white woman and three African Americans, including Martin Delany, from the entering class of the Harvard Medical School.[38] Soon a much larger debate arose surrounding the Fugitive Slave Act of 1850. Boston resistance began early in 1851, when activists swept into a municipal court and spirited away the black defendant, Shadrach Minkins. He was sheltered overnight at Reverend Lovejoy's home in Cambridge before being hustled to safety in Canada.[39] Two months later, protests failed to stop the rendition of Thomas Sims back to Georgia, despite efforts by the Boston Vigilance Committee.[40]

The next year, 1852, a related debate erupted with the publication in Boston of *Uncle Tom's Cabin* by Harriet Beecher Stowe, the daughter of Charles Homer's former minister. Higginson quipped that a book of his own was "at a standstill because Mrs. Stowe exhausts all the paper mills."[41] Cambridge took special note, since everyone knew that Stowe's sister Mary, living on Prospect Street, had sheltered the Clarke brothers after their escape from Kentucky. Gossip had it that the famous author had met Lewis Clarke on a visit and then used him in the novel when creating George Harris, Eliza's husband.

In 1854, federal agents in Boston arrested an ex-slave named Anthony Burns, and confrontations escalated. The date of Burns's arrest, May 24, also saw the passage in Congress of the Kansas-Nebraska Act, opening the West to slavery. Democrats fired off cannons on Boston Common in celebration.[42] By June 2, "Bad Friday," the city of 140,000 was bitterly divided. Protesters lined the streets as armed guards escorted Burns to a revenue cutter in Boston harbor. By one estimate, "Fifty thousand spectators witnessed the procession as it made its way past buildings draped in black."[43]

The date Burns was arrested happened to be the day sixteen-year-old Charlotte Forten began keeping a diary. Forten came from a prominent black abolitionist family in Philadelphia and was attending school in Salem, Massachusetts. She devoted her first pages to the legal deportation of Burns, calling it a "cruel outrage on humanity." "I can write no more," she concluded on Bad Friday. "A cloud seems hanging over me, over all our persecuted race, which nothing can dispel."[44] Homer would not have felt as emotional as Forten, but he surely pondered this growing cloud, as several of his key prewar images suggest.[45]

In 1856, Homer created *Arguments of the Chivalry*, depicting Representative Preston Brooks of South Carolina caning Charles Sumner in the Senate chamber (Figure 2). The Republican senator from Massachusetts, who had delivered a scathing anti-slavery oration on "The Crime against Kansas," was badly injured in the attack. Homer placed a quotation from Henry Ward Beecher across the top: "THE SYMBOL OF THE NORTH IS THE PEN; THE SYMBOL OF THE SOUTH IS THE BLUDGEON."[46]

In February 1857, on his twenty-first birthday, Homer ended his apprenticeship at Bufford's and became a freelance artist. Two weeks later, the Supreme Court issued its sweeping anti-

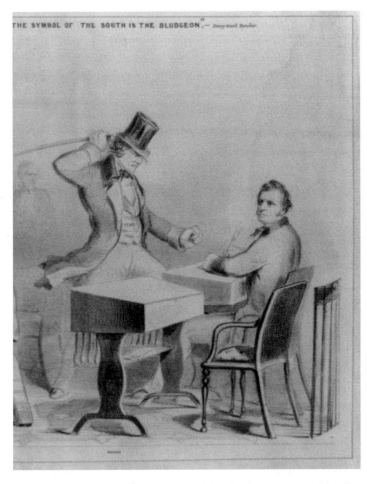

"THE SYMBOL OF THE SOUTH IS THE BLUDGEON."

FIGURE 2. Winslow Homer, *Arguments of the Chivalry*, 1856 (Detail). Lithograph. Library of Congress, Washington, DC.

black decision in the Dred Scott case, and the reaction in Boston was immediate. William Cooper Nell, the outspoken black historian, pointed out that the ruling had been handed down

on March 5, the date of the martyrdom of Crispus Attucks in the Boston Massacre of 1770. So the next spring Nell led local African Americans in organizing a Commemorative Festival on March 5 at Boston's Faneuil Hall, paying tribute to both Attucks and Scott, in order to link past and present struggles.[47]

Homer may have noticed the event, but it did not appear in his art work. He continued to sell innocuous images that the popular press desired, using local subjects he knew well. For example, when *Harper's Weekly* in New York published its first Homer pictures in August 1857, they were Harvard scenes for an article on New England college life. The editors admired his work, and late in 1859 the aspiring artist moved to New York City. The next year, after the fall election, his reputation earned him the plum of engraving the image of Abraham Lincoln for the cover of *Harper's*. To introduce the newcomer, Homer used Mathew Brady's famous Cooper Union photograph, taken in New York earlier that year. He added a prairie in the distance and grapes at the president-elect's elbow, perhaps to suggest he would labor in a difficult vineyard.[48]

Lincoln's was not the only important face Homer engraved that winter. As the Secession Crisis mounted, Homer used Brady portraits to create other *Harper's* covers. They showed various southern politicians who were resigning from Congress, including Senator Jefferson Davis at the head of the seceding Mississippi delegation.[49] He also made a dramatic image of Frederick Douglass being dragged from the stage at a crowded meeting in Boston, called to observe the first anniversary of John Brown's execution (Figure 3). "Expulsion of Negroes and Abolitionists from Tremont Temple" captured the explosive atmosphere during the weeks after the 1860 election.

It was during this time, according to a contemporary, that Homer "determined to paint." Following a night-school class in

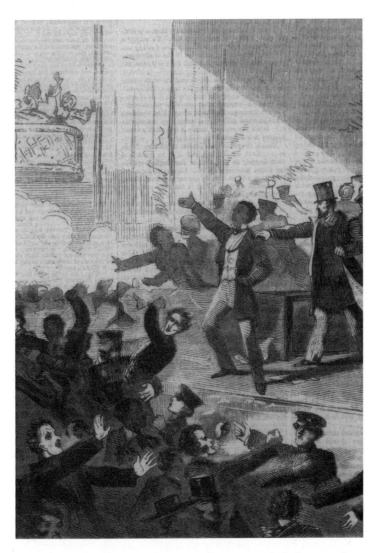

FIGURE 3. Winslow Homer, "Expulsion of Negroes and Abolitionists from Tremont Temple, Boston Massachusetts, on December 3, 1860" in *Harper's Weekly* (December 15, 1860) (Detail). Wood engraving on paper (6^{15}/16 × 9^{1}/8 in.). The Museum of Fine Arts, Houston; The Mavis P. and Mary Wilson Kelsey Collection of Winslow Homer Graphics (75.670).

New York at the National Academy of Design, he took painting lessons from Frederic Rondel, "who, once a week, on Saturdays, taught him how to handle his brush, set his palette, &c." In March 1861, Homer covered Lincoln's inauguration. War erupted in April, and by June, the artist was back in the Boston area. Spending the summer in Belmont, "he bought a tin box containing brushes, colours, oils, and various equipments, and started out into the country to paint from Nature."[50]

Funds being scarce, Homer also continued to draw for *Harper's*. He sketched war preparations at the Watertown Arsenal and sailors leaving Boston Harbor.[51] The latter picture, showing a motley group of naval recruits on a Boston dock, hit close to home, for in September Winslow's younger brother Arthur joined the navy and sailed for Key West aboard the USS *Kingfisher*. Then in October, Fletcher Harper of *Harper's* informed Winslow that he was to be embedded (as we now say) with the newly forming army of Major General George B. McClellan.[52] "I am off next week," Homer wrote to his father, "instructed to go with the skirmishers to the next battle." He boasted that he had the confidence of John Bonner, his managing editor. "Bonner thinks Homer is smart," he wrote, "and will do well if he meets no pretty girls down there, which he thinks I have a weakness for. I get $30. per week RR fare paid but no other expenses."[53]

By the time Homer set out for the war, he had already gained several things his biographers overlook. First, coming of age in Cambridge had given him a keen, if abstract, awareness of the slavery issue. In addition, working for a popular weekly put him in contact with illustrators who were perfecting a form of acute, often veiled, visual commentary that led to modern political cartooning. Specifically, a nineteen-year-old immigrant, Thomas Nast, started drawing for *Harper's* in

1859. In coming years, as Homer honed his illustrating craft and his painting skills, he would continue to learn from this association.[54]

That said, it still seems unlikely that so early in his career Homer had clear views that we would call overtly "political." If he did, we know little about them—though his father was an early admirer of John C. Frémont, the Republican Party's first presidential candidate in 1856. Instead, it seems that Homer already, at the outset of the Civil War, felt a more general identification with the lives and sensibilities of outsiders. Figures perceived by most as standing on the margins of society—women, children, rural workers, sailors, African Americans—would be the focus of many of his best later works.

Nowadays, we can discern Homer's underlying respect for people with little power. In the Newark image, for example, most current viewers sense the artist's understated empathy. But that was hardly true when the Corbins recovered the picture from their father's attic. At first, Lin Eberstadt described the painting brusquely as *colored woman in doorway.* Terry Corbin felt she "seems to reflect a mood of depression and possible bewilderment." In his undergraduate paper, he speculated, "Perhaps she is sad because of the way in which the war has disturbed the peaceful way of living in the South. Perhaps she feels that her security on the plantation has been threatened." The Newark Museum simply introduced the woman as "a young Negro girl."[55]

But what about a century earlier? How did this same work appear to its initial audience? I wondered why no one had ever managed to complete the provenance started by Eberstadt. It would surely involve some strange twists, but solving that riddle would provide an answer to an intriguing question: If

Winslow Homer's background gave him reason to paint this unlikely picture, who had the right combination of resources, interest, and understanding to want to own it in 1866?

The Owner Teaches School at Port Royal
She was the light of the house, and the main pillar of the school.

One thing struck me as strange when I went through the Newark Museum's files. It involved Eberstadt's summary in 1962 about how Homer's picture had entered the Corbin family. Robert Corbin had mentioned to him that the painting "is presumed to have been acquired by Louise Kellogg." Her dates were uncertain, but Eberstadt was told that she "had an intense interest in the South where she traveled immediately after the Civil War when she was in her early 40's. She contracted typhoid and is buried in Elizabeth, New Jersey." Eberstadt recalled hearing that, after her sudden death, the painting had been retained by a parent and then handed down through the family.[56]

The Corbins, however, did not include these details in the signed provenance they returned to Eberstadt. Their revision simply attested to the fact that this "Civil War scene . . . was in the possession of Elijah Kellogg's . . . family prior to 1884." Apparently, the five siblings could not all vouch for the lore Eberstadt had heard the previous week regarding Louise Kellogg.[57] But four years later, bits of the story resurfaced. After acquiring the picture in 1966, the Newark Museum staff heard references to a mysterious Kellogg family member with possible links to Homer.

When Robert Corbin visited the museum, a staff member jotted down his recollections. "Aunt Mary talked about the

painting," one note recorded; the picture "could well have been given by Homer. . . . Legend is that one of [Elijah] Kellogg's maiden daughters went down south during Civil War–there she met Homer and he gave it to her." Another questioning note stated: "Mr. Corbin . . . didn't know *definitely* how the painting came into the family. One of his [father's] aunts was an abolitionist; went South and perhaps came home with the painting??"⁵⁸

The museum seemed inclined to discount these leads. Answering one query from an art scholar, the curator mentioned "a family tradition" that "Mrs. Kellogg had traveled to the South during the Civil War, had met Homer, and was given the painting. However," he added, "this story seems very unlikely and could not be confirmed."⁵⁹ Evidently, no one had tested this elusive "family tradition" by looking for someone (perhaps named Louise), with abolitionist leanings and a close tie to Elijah Kellogg, someone who might also have a link, direct or indirect, to Homer himself.⁶⁰

Elijah Kellogg (1784–1856) became a prominent figure in antebellum Elizabeth, New Jersey; a park given to the city by one of his sons in 1871 still honors the family name. With his second wife, Martha Crane Kellogg, Elijah had five children. The youngest, Clementine, married a lawyer named William Horace Corbin in 1878. The Homer picture already hung in Martha Kellogg's dining room, long before Mrs. Corbin inherited it from her mother in 1908, the year her own son, Horace Corbin, graduated from Princeton. Horace and his older brother Clement knew their mother's sister, Mary Kellogg. "Aunt Mary," three years older than their mother, would have remembered the war years fully, and she must have talked vividly about two much older half-sisters, born shortly before the death of their mother, Ann Maria Kellogg.

Ann Maria, Elijah Kellogg's first wife and the mother of nine, had died on Christmas Eve, 1831. The youngest children she left behind, two very small girls, were raised by their step-mother; each grew up to be a strong, independent teacher who never married. One, Julia Antoinette (b. 1830), had a long and varied career.[61] But the other, Sarah Louisa (b. 1828), died suddenly in midlife, at age 38, on June 24, 1866. She was sufficiently prominent and admired at the time of her death to merit an obituary notice in the *New York Times*. It named her as Sarah Louise Kellogg—not Louisa, so that is probably the name by which she was known. After a funeral service at the Kellogg home, burial took place at Evergreen Cemetery in Hillside, New Jersey. Cemetery records list "Consumption" as the cause of death.[62]

Kellogg's life, though cut short, had been eventful. An 1877 genealogy of the family included this surprising editorial comment: "During the last two years of her life, she was engaged at Port Royal, South Carolina, in active efforts for the education of the freedmen, and in that cause contracted the disease which terminated her valuable and heroic life."[63] The full entry made clear that, in contrast to versions of the family saga, she was not *Mrs.* Kellogg, but Miss; she went south *during,* not after, the Civil War; and she had died in her *late thirties,* not her early forties. Moreover, the Port Royal reference seemed worth pursuing. After all, Civil War historians knew how Union gunboats, early in the conflict, had liberated thousands of enslaved African Americans in the Sea Islands by seizing control of Port Royal Sound.

"The Big Gun Shoot" of November 7, 1861, lived on in black oral tradition. Years later, ex-slave Sam Mitchell recalled how, as a boy, he heard strange thunder and watched white planters departing for Charleston. "Son," his mother told Sam, "'dat ain't

no t'under, dat Yankee come to gib you Freedom."[64] In St. Helena Parish, "eleven hundred white people fled" almost overnight, South Carolina's Theodore Rosengarten explains, "leaving behind seventy-eight hundred blacks"—the vast black majority.[65] Northern efforts soon led to the creation of the Penn School on St. Helena Island, an educational institution founded in the 1860s by Laura Towne. A century later, in the 1960s, Penn Center provided a meeting place for Civil Rights leaders, and in 1964 (the same year that Homer's *Captured Liberators* first went on display at Bowdoin College) historian Willie Lee Rose published *Rehearsal for Reconstruction,* reaching back a century to detail the dramatic story of the "Port Royal Experiment" for the first time.

Rose's pioneering work described the efforts of scores of zealous black and white teachers from the North who headed to Port Royal, starting in 1862. Deeply committed, and hence known as "Gideon's Band," these men and women, such as Laura Towne of Pennsylvania, labored to bring literacy and education to black South Carolinians liberated by the Union fleet late in 1861. "The teachers" had to possess "the most serious missionary spirit," recalled one historian, to resist skeptics, both North and South. "Ostracism is a mild term," he wrote, "for the disesteem with which they were regarded as 'nigger teachers.'"[66]

But others held them in high esteem. A black man at the turn of the century recalled these "noble women" as "sustained by an unbounded enthusiasm and zeal amounting almost to fanaticism." They had left their "homes, their friends, their social ties, and all that they held dear, to go to the far South." For their "courage . . . devotion . . . and . . . faith," they seemed worthy inheritors of the original Puritan errand.[67] Their initial leader, Bostonian Edward L. Pierce, spoke to the first band of Gideonites as

they approached Beaufort, South Carolina. He assured them: "never did a vessel bear a colony on a nobler mission, not even the Mayflower," adding, "it would be a poorly written history that would omit their individual names."[68]

But did these names include Sarah Louise Kellogg? She was not in Pierce's initial vanguard, and *Rehearsal for Reconstruction* made no mention of such a person. Records did contain occasional references to Miss K, Miss Kellogg, and even Louise Kellogg. But a 1941 study of the northern teachers by Henry Lee Swint asserted that all these references concerned a woman from Avon, Connecticut, named *Martha* Louise Kellogg.[69] Later scholars have accepted Swint's verdict, but initial delving suggested to me that the real story was more complicated.[70] A Martha Louise Kellogg did teach in the South, and she even taught briefly in wartime South Carolina.[71] But the 1877 genealogy made clear that Sarah Louise also taught at Port Royal. Could she, instead of Martha Louise, be the Kellogg woman mentioned in the journals of Towne and Forten? Further digging seemed to be in order.

I began with the diary of Charlotte Forten, started during the Burns Trial in Boston, because a decade later she was teaching on St. Helena Island, near Port Royal. In May 1864, ill and preparing to leave for home, she made a final South Carolina entry, writing at the Oliver Fripp Plantation where she had been living since 1863. She would miss her fellow teachers, especially the ones with whom she lived. "Our household consists of Mr. Sumner and Mr. Williams and Miss Kellogg. They are all most pleasant and congenial companions," she wrote; "our winter has been passed pleasantly together."[72]

Maybe one of these Gideonites had written letters that could tell me more. In the Penn School Papers at the Southern His-

torical Collection in Chapel Hill, North Carolina, I found a letter by Arthur Sumner of Cambridge, written from St. Helena in February 1865. He described the arrival of Sherman's forces in Beaufort, and then added this:

> My dear friend, Miss Kellogg has gone away from us. She is ill; her lungs are sadly diseased, and so she has gone North. She was the light of the house, and the main pillar of the school. So good, so amiable, and pleasant, so efficient and sensible, so honest and kind—how can we get along in this gloomy house without her? And I fear she is not long for this world. I lost another friend named *Sarah (that is Miss Kellogg's name)* by consumption. . . . Woe is me![73]

Finally, in this brief parenthesis, here was the "heroic" Kellogg woman—Sarah Louise, *not* Martha Louise—stricken with tuberculosis (then known as consumption). Perhaps only Sumner, her admiring housemate, used the endearment "Sarah," while other friends called her Louise. "Poor Louise Kellogg is ordered home," Laura Towne had written several weeks earlier. "There is a tendency to lung disease in her family, which has always made her afraid of the cough which she has. This winter it has been much worse . . . and she expects to go by the next steamer. She has had several quite severe attacks like lung fever and has not been well all winter," Towne reported sympathetically. "She is almost heartbroken at leaving her school. I am so sorry she is going."[74]

The extent of Miss Kellogg's commitment to the cause and the seriousness of her illness were clear to all around her, and Towne and Sumner mourned her departure.[75] Their earlier letters confirm that this "lovely and lovable . . . New York lady"[76] had been teaching in South Carolina through 1863 and 1864.[77]

In one letter, Arthur Sumner offered a glimpse of their dedicated daily life. "We expect unusual satisfaction with our school this season," he wrote. "Three teachers, in separate rooms, are hammering away upon the heads and hands of two hundred children. We have seven classes in Reading and Spelling; one Alphabet class of about twenty; three in Writing; and one in Geography. . . . It is a great pleasure to me to get back to the old house and the school."[78]

One intriguing detail deserves special note. Of all the Union ships moving in and out of Port Royal Sound, the one the teachers knew best, by far, was none other than the USS *Kingfisher*, with Winslow Homer's brother Arthur aboard as a crew member. The vessel patrolled St. Helena Sound from December 1862 until March 1864, so for fifteen months the teachers became well acquainted with Captain Dutch and his crew, even dining on board. Today we "took boats for the Kingfisher," Laura Towne recorded, "spending some hours on the ship admiring the exquisite order and cleanliness."[79] The implications are clear, if inconclusive: the Homer family had an obvious stake in all that transpired at St. Helena in these months and may have heard about these visits. Quite possibly, Sarah Kellogg encountered Arthur Homer, and she might even have met his brother after she sailed back to New York City. Whatever the case, she was clearly the maiden aunt, with "an intense interest in the South," who had been linked by family lore to the Newark Museum's picture that dated from 1866, the year of her death.

But why had Sarah Louise Kellogg, the apparent first owner of Homer's painting, dropped out of view for an entire century? At first, even as the Port Royal teachers dispersed and moved on to other causes, the story of Gideon's Band was kept alive. In the Kellogg and Corbin families, Sarah's service in the Sea

Islands was recalled by Aunt Mary and others for decades.[80] Her devoted sister Julia even visited Laura Towne at the Penn School in 1868.[81] But gradually, as the unique painting was passed down across generations, its surface darkened and the relevance of its subject faded. Family members forgot the picture's title and the name of the artist who made it. Any recollection of the wartime dedication that linked Sarah Kellogg to the woman inside the frame had grown faint indeed by the 1960s, when Homer's painting came down from the attic.[82]

BEHIND ENEMY LINES

Captain Wirz's Prison

. . . the poignancy of the canvas is increased ten-fold.

Even after Winslow Homer's painting found a public home in the 1960s, it went virtually unknown for two decades. It never traveled, and even its true title remained a mystery. Since dealer Lindley Eberstadt had christened the painting *Captured Liberators* in 1962, the Newark Museum kept that name when it acquired the work in 1966. But Homer scholar Lloyd Goodrich disapproved, arguing that "the picture should be titled: *At the Cabin Door.*" Later, Edith Goodrich (his wife and coworker) wrote, "In view of the fact that no former title has been found for it and that *Captured Liberators* seems strangely inappropriate for Winslow Homer, we hope that the Newark Museum will adopt Lloyd's suggestion of *At the Cabin Door* as the title."[1] Anxious to accommodate the Goodriches, the museum promptly altered the name of the picture.[2] Twenty years would pass before the actual title surfaced a continent away in San Francisco.

The story begins in the late 1970s, when Mr. and Mrs. John D. Rockefeller III donated a large collection of American art works to The Fine Arts Museums of San Francisco.[3] Their stunning gift included Winslow Homer's *The Bright Side* (1865), which shows black teamsters in an army camp during the Civil War (Plate 2). In 1985, that picture sparked curator Marc Simpson to conceive a national show entitled *Winslow Homer Paintings of the Civil War*. The exhibit would open in San Francisco in 1988,

showcasing *The Bright Side* and putting the work into its historical and artistic context for the first time. Naturally, Simpson wanted to include Newark's *At the Cabin Door,* since it remained one of the least known of Homer's Civil War paintings. The artist had started it in 1865, the same year as *The Bright Side,* and, though very different, it even contains similar elements of design. In each, a distant army scene and open sky fill the upper left; at the center, an alert, enigmatic black figure emerges from a simple dark abode into the light.

By the summer of 1987, the search was on to learn more about *At the Cabin Door.* "Unfortunately," Newark reported to Simpson, "our files are very skimpy."[4] But in San Francisco, Simpson and his assistant Sally Mills hit pay dirt. A local art dealer offered to share his "indexed digest" of all the art criticism in the *Evening Post,* a Civil War–era newspaper in New York City. Within minutes, the two California prospectors had struck gold: a small item from April 19, 1866, announcing that an "auction sale" of pictures by twenty-eight American artists would take place that evening at the Miner & Somerville Gallery, on Broadway at Tenth Street.[5] Singling out several artists by name, the notice observed that Winslow Homer was presenting half a dozen "vivid scenes of army life." These works included *Pitching Quoits* (1865), plus another "depicting a negro woman standing at the door of her cabin, gazing at Union prisoners as they pass." *The Evening Post* observed that this particular image was "full of significance" and was "entitled 'Near Andersonville'."[6]

Suddenly, more than 120 years after the picture's creation, here at last was a firsthand description that linked the canvas with its original name, given by the artist. "In the course of prowling through old newspapers," Simpson wrote to the Newark

Museum, "I believe that we have found *At the Cabin Door*'s 19th-century title." Finally, he reported, "your canvas can be definitively linked to a work that Homer" displayed in New York in April 1866. Simpson conceded that *Captured Liberators* and *At the Cabin Door* had been "close in spirit" for titles, but he underscored the importance of the new discovery: "the poignancy of the canvas is increased ten-fold by having Andersonville associated with it."[7]

Simpson's find also helps to complete the puzzle regarding the painting's first owner. The auction date of April 19, 1866, shows that Homer displayed his picture two months before the death of Sarah Kellogg on June 24, so she could indeed have possessed and appreciated *Near Andersonville,* if only briefly. The ailing teacher had returned from South Carolina early in 1865, but her health had grown worse. Did she see the auction catalogue and purchase the picture, or did a sympathetic friend obtain it for her? Perhaps Arthur Sumner, her admiring housemate in South Carolina, used his Cambridge connections to arrange the gift. Or did Homer himself know of Miss Kellogg, through his brother's service at Port Royal aboard the *Kingfisher?* He could have presented her with the picture, as suggested by bits of family lore. Perhaps, now that the first owner's identity is known, additional details will surface.

Meanwhile, the discovery of the picture's title, *Near Andersonville,* dictates the need to revisit that deadly prisoner-of-war camp. Officially known as "Camp Sumter," Andersonville held Union captives only during the final year of the Civil War, but it rapidly became the Confederacy's biggest and most notorious POW facility. Located in southwest Georgia, it was situated fifty miles below Macon—and two hundred miles west of Port Royal, where Sarah Kellogg was teaching in the summer of 1864. The camp had taken shape the previous winter, as the

Belle Isle and Libby prisons in Virginia grew more crowded. The influx of captives strained resources around Richmond and made the Confederate capital vulnerable to a prisoner uprising or a raid designed to liberate thousands of Union soldiers. The sudden breakdown in North–South prisoner exchanges compounded Virginia's overcrowding problem. POW exchanges—extensive early in the war—nearly ground to a halt in 1863 with the appearance of black soldiers in Union ranks. Former slaves made up the vast majority of the Union's so-called "colored troops," and the Confederacy insisted that such soldiers, when captured, would be treated as rebellious runaways, not military prisoners. In the war-weary North, officials felt obliged to stand up for black recruits; their manpower was becoming vital as resistance mounted to drafting more white soldiers. Abolitionists and black enlistees argued that the government should cease trading POWs, to protest the South's reenslavement policy. Despite protests, Union strategists agreed, calculating that an end to exchanges would eventually favor the more populous North. Since neither side would give in, negotiations to end the stalemate broke down.[8]

In Richmond, therefore, pressure increased to create a large new prison camp, remote from enemy lines. The tiny, hardscrabble railroad depot of Andersonville, Georgia, seemed suitably isolated. In January 1864, construction began on a stockade, intended to contain ten thousand people at most. But manpower and supplies were extremely limited; when the first trainload of prisoners arrived in late February, no hospital or barracks existed, and one stockade wall remained unfinished. The tangled command structure for prison oversight did not help, nor did the abrasive personality of the camp's commander, Henry Wirz. (Captain Wirz, a Swiss-born immigrant from the Fourth Louisiana Infantry, had been shot in the right forearm during the

Battle of Seven Pines in Virginia; the injury remained a source of chronic discomfort that added to his irascible nature.)[9]

Within days, smallpox broke out, and conditions worsened each month as the heat increased. The camp's narrow stream turned into a polluted swamp, and with numbers mounting other diseases spread—scurvy, dysentery, diarrhea, typhoid, and pneumonia. Guards shot men who wandered across the confining "dead line," and bloodhounds trained to chase runaway slaves tracked down escaping prisoners who slipped away from burial duty. Despite a rising death rate, the population of the eleven-acre camp had risen above twenty-five thousand by the end of June. "That worked out," one historian calculates, "to barely twenty square feet of ground per man: almost precisely the surface area of a common grave."[10]

In July, Captain Wirz expanded the perimeter to twenty-five acres. This provided a slight respite, but by August the crowded camp had swollen to more than thirty-three thousand prisoners, making Andersonville the fifth-largest city in the South. For that sweltering month, the death toll averaged ninety-six per day, or four per hour. Over fourteen months, the Confederacy incarcerated roughly forty-one thousand prisoners at Andersonville, and nearly thirteen thousand—almost one in three—died there under horrifying circumstances.[11] Outside, local slaves and some captured black soldiers were impressed to work at "felling trees, making roads" and building fortifications. "They often get lashed by their masters or overseers," wrote one POW, "as we can hear their cries of pain plainly over at the log house village of Andersonville on still nights."[12]

Hints of the horrendous conditions in and around the camp reached the North during the summer of 1864.[13] Its infamy increased the next spring, after Appomattox, as survivors made their way home. Many were too weak, or too unlucky, to com-

plete the journey. When the overloaded transport vessel *Sultana* blew up on the Mississippi north of Memphis on April 27, more than sixteen hundred veterans were killed in the nighttime explosion—the worst maritime disaster in American history—and "most of those who died had come from Andersonville."[14] But others did reach home, giving the prison huge symbolic importance across the North, even before May 1865, when the last survivors left Andersonville and Union cavalrymen arrested Captain Wirz.[15] Throughout the summer and fall—as Homer presumably was developing his painting—Andersonville remained in the national spotlight.

In July, Clara Barton made a working visit to the deserted camp to repair the cemetery. She later published a full report of her expedition, addressed directly "To the People of the United States." She explained:

> During the occupation of Andersonville as a prison, it was a punishable offense for a colored man or woman to feed, shelter, aid, or even converse with a prisoner on parole. To others they had no access. I have been informed that they were not allowed around the prison grounds; and so great was their . . . horror of the cruelties perpetrated upon the prisoners that only a comparatively small number had ever found the courage to visit the cemetery up to the time of our arrival. But the presence of so many northern people on such an errand, and especially a lady, entirely overcame their fears, and they visited the cemetery and myself by scores, men, women and children, sometimes 100 in a day.[16]

Barton labored in the heat with others, black and white, putting lettered headboards on thousands of graves, and on August 17 she dedicated the Andersonville National Cemetery and raised the American flag.[17]

A week later, on August 23, Captain Wirz was brought before a special military tribunal in Washington, and for several months his trial captured national headlines. *Harper's Weekly* ran regular updates, including a two-page spread re-creating grim prison scenes.[18] The *New York Times* even sent a correspondent to Georgia to visit the stockade.[19] Finally, whether as an emblem of wrongdoing or as a ready scapegoat, Wirz was sentenced to death, the only Confederate official tried and executed for war crimes. In November, on the site of the future Supreme Court Building, Wirz went to the gallows amid acrimonious debate.

The contested history of Andersonville lived on through Reconstruction and beyond. By the early twentieth century, fourteen northern states had erected imposing monuments at Andersonville National Cemetery. But it antagonized the United Daughters of the Confederacy (UDC) to see northern memorials in the heart of segregationist Dixie, especially since "thousands of Northerners and Southern Negroes" now assembled annually in Andersonville on the last weekend in May "for Memorial Day exercises." So in 1905, forty years after the execution of Wirz, the organization began raising funds for a competing monument, designed "to rescue his name from the stigma attached to it by bitter prejudice." In 1909, the UDC placed a 45-foot column in the village of Andersonville to honor Wirz, and it still stands there a century later.[20]

Eastman Johnson's Shadow

. . . he had become the premier painter of African American life.

We shall return to Andersonville, but first we need to pick up Homer's developing career, looking first at the artist who influ-

enced him most directly, and then at Homer's own sudden exposure to warfare, slavery, and the South. When we left him, the *Harper's* illustrator was heading to Washington in October 1861, instructed by his editors to link up with McClellan's army. Soon he had found lodgings and was venturing out to explore the wartime capital and sketch his surroundings. "We hear often from Win," his mother wrote proudly to her youngest son Arthur aboard the USS *Kingfisher;* "he is very happy, & collecting material for future greatness."[21]

One of Win's first outings involved a visit to George Washington's estate. Homer may have made the trip to Mount Vernon with his friend Alfred Waud, an English-born illustrator he knew well from Boston. In December, Waud published a picture in *The New-York Illustrated Journal* showing Union soldiers headquartered in Alexandria who had made the popular pilgrimage down the Potomac to visit Washington's grave. Homer also made a sketch, but from a very different angle. His small drawing, done with pencil, ink, and watercolors, depicts the famous house in disrepair, with dark and vacant windows (Figure 4). Small black figures are seen emerging from a low side door, and leafless trees suggest that harsh weather lies ahead.

The picture links back to Homer's Cambridge days via two important individuals, Edward Everett and Eastman Johnson. No one did more to spur interest in Mount Vernon than Everett, the former U.S. senator and president of Harvard (who would precede Lincoln as a speaker at Gettysburg in 1863). In the 1850s, the great orator had toured the country, raising money to restore Washington's home as a national shrine. His rousing lecture linked the shabby state of Mount Vernon with the shaky condition of the national union.[22]

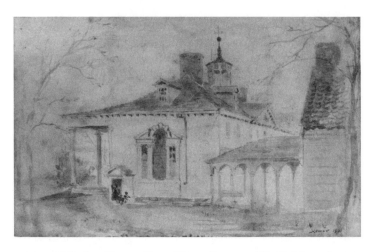

FIGURE 4. Winslow Homer, *View of Mount Vernon and North Colonnade*, 1861. Ink, watercolor, and pencil on paper (5⁷⁄₁₆ × 8⁹⁄₁₆ in.). Courtesy of the Mount Vernon Ladies' Association.

Homer no doubt accepted Everett's prevailing view of the stately home as an emblem for the nation itself. So the African Americans in the drawing may evoke slaves "stealing away" to the North. This hint of black movement from the South's most famous plantation had become more than a metaphor by late 1861, for Mount Vernon stood in the neutral zone between the contending armies. Blacks still living in bondage there were being deported to the slave market in Richmond, prompting others to scramble to reach Union lines before they could be sold further south.[23] Meanwhile, at Fortress Monroe near Norfolk, General Benjamin Butler, the Yankee lawyer turned Union officer, had declared escaping slaves to be "contraband of war," hastening the black exodus across eastern Virginia.[24]

Homer's Mount Vernon sketch signals the influence of another Cambridge connection: artist Eastman Johnson from

Lovell, Maine. Twelve years older than Homer, Johnson had also spent several years working in a Boston lithography shop. In 1846, Henry Wadsworth Longfellow invited him to Cambridge to draw various friends, including Emerson and Hawthorne. The portraitist, in his early twenties, remained in the area until 1849, so young Homer may have glimpsed Johnson or seen his work. (He certainly knew Longfellow's impressive house on nearby Brattle Street.) But it was in the next decade that Johnson's work clearly caught Homer's attention and may have left its mark on some of Homer's images of African Americans, starting with the Mount Vernon image.[25]

Johnson had made his own pilgrimage to Washington's estate in 1857, and his painting of *The Old Mount Vernon* is warmer than Homer's sketch. But it shares exactly the same south-facing vantage point, and it too contains black figures. Did Homer have Johnson's picture in mind four years later, and if so, was he trying to comment on it, build on it, or compete with it? The question is relevant, because a number of Homer's pictures of black subjects seem to relate to earlier works by the older artist.[26]

Compare the form and content of *Near Andersonville* with Johnson's earlier painting, *A Ride for Liberty—The Fugitive Slaves* (Plate 3), which shows a slave family on horseback as they make a sudden dash for freedom. Johnson had witnessed such an incident in Virginia, early on March 2, 1862, as McClellan's forces advanced to Manassas. On the left, the bayonets of distant troops reflect the morning sun. Johnson's *Ride for Liberty* is filled with horizontal motion, while Homer's later picture is largely vertical and stationary. But in each, soldiers march in the distance, while black figures with their minds set on freedom dominate the foreground.

Two other Johnson pictures also prefigure *Near Andersonville*. *The Freedom Ring* (1860) is set in the North, not the South, and it

depicts a nearly white girl rather than a grown black woman. But it too puts a female contemplating emancipation at the center of the frame. *Union Soldiers Accepting a Drink* (1865) has a southern setting, but it is greener and more hopeful than Homer's painting; it has ripening apples and sunflowers instead of gourds, and it contains no captives. But as in *Near Andersonville*, a black servant who stands in a shadowed doorway is linked to the liberating troops, and a pensive young slave woman in the center of the picture ponders her uncertain future.[27]

A full comparison of the way these two artists dealt with race and slavery has yet to be written.[28] But we can be certain that Homer knew Johnson's famous picture, *Negro Life at the South* (Plate 4). Art scholar Patricia Hills observes that this single painting "catapulted" Johnson "to the forefront of New York image-makers" when it appeared in 1859. The picture, sometimes known as *Old Kentucky Home*, was "quickly embraced by both high and popular culture. Perhaps without even calculating the potential of the subject, he had become the premier painter of African American life."[29] Apparently, the image was also respected in both North and South. No doubt Homer studied the way that Johnson delved into a controversial topic (through the eyes of the sympathetic white intruder on the right) while still engaging a varied audience.

Experts differ in their interpretations of Johnson's painting. But I take *Negro Life* in part as a rumination on Lincoln's "House Divided" speech, which came at the start of his failed 1858 campaign for the U.S. Senate. The Illinois candidate echoed Everett's imagery of the national home. "A house divided against itself cannot stand," Lincoln asserted; "this government cannot endure, permanently half *slave* and half *free*."[30] In Johnson's picture, the crumbling edifice of southern slavery, seen in a reveal-

ing backside view, still remains connected at its foundation to the more solid and sunny building that adjoins it. While working on *Negro Life*, Johnson rented a studio in the University Building on Washington Square, where Homer also occupied space after 1862. The two men saw each other often, and in 1865, a nomination from Johnson helped Homer gain election to the prestigious Century Club—"a prime venue for making contacts with potential patrons."[31]

If Homer watched Johnson closely, he also pursued an independent path, working steadily for a national weekly as he developed his skill with oil. Even with *Sharpshooter* (1862/63), "his very first picture in oils," he began to establish himself as the Civil War's most original painter.[32] According to Steven Conn and Andrew Walker, he "used his observations of the conflict" to conceive a number of works "that might well be called history paintings, iconic images that succeeded in capturing the public imagination" even more than the works of better-known artists, such as George Inness and Eastman Johnson. They include *The Veteran in a New Field*, plus *The Bright Side* (Plate 2) and *Prisoners from the Front* (Plate 5), in this assessment.

Such well-known Homer pictures moved the artist out of the shadow of Eastman Johnson. "These paintings," Conn and Walker write, "succeed where others falter not simply because the artist abandoned history painting's conventions, although he certainly did that. More importantly, instead of relying on the narrative models of traditional history painting, he invented a new language and vocabulary with which to engage the complexities of historical 'truth.' In so doing," the two scholars conclude perceptively, "he replaced the heroic action, moral confidence, and didactic certainty of grand-manner history painting with ambiguity, ambivalence, and even irony."

One might wonder why they did not cite *Near Andersonville* as well.

For Conn and Walker, therefore, *Prisoners from the Front* represents "history painting of a new kind. Homer's work derives its power from its ability to express a variety of different, and indeed conflicting, messages about the nation's fratricidal catastrophe. Ambiguity, not moralizing, lies at the heart of this painting."[33] It appeared initially at the annual exhibition of the National Academy of Design in mid-April 1866, and this impressive work remains a memorable icon of the conflict. Ironically, *Near Andersonville* was first displayed that same week. *Prisoners,* a balanced and accessible tableau of white opponents, burnished Homer's growing reputation and attracted generations of art commentary. The other, more challenging picture—portraying Union prisoners in Georgia, as seen from the perspective of an African-American woman—disappeared by happenstance, lost from public view for a full century.

Winslow Homer's War

. . . so changed that his best friends did not know him.

During the decades since *Near Andersonville* emerged into the light and finally regained its original name, numerous exhibits and essays have probed Homer's Civil War art. They have expanded and deepened our understanding of his early career, and I shall not recount all their findings in detail.[34] Instead, I want to stress three key points about Winslow Homer's Civil War; they concern trauma, growth, and an intuitive empathy for black America. Regarding trauma, we appreciate Homer's influence on our view of the war, but we remain less clear about the influence of the hostilities on the painter himself. Surely,

we reason, the impact could hardly have been large, since at most he spent months, not years, with the army on three or four separate visits. Besides, after a postwar visit to Europe, he went on to an amazingly versatile and productive career.

Still, consider Homer's involvement in McClellan's bloody Peninsula Campaign of 1862. He was present at the siege of Yorktown in April, constantly making sketches. Before leaving Virginia in early June, he saw the carnage from the chaotic Battle of Seven Pines near Richmond—five thousand Union casualties in two days. He quickly gained, and conveyed to viewers, a sense of warfare and its aftermath. In July, Homer published several violent scenes in *Harper's* based on his time in Virginia, including "A Bayonet Charge" (Figure 5) and a stark

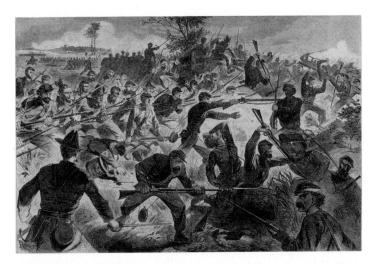

FIGURE 5. Winslow Homer, "The War for the Union—A Bayonet Charge" in *Harper's Weekly* (July 12, 1862). Wood engraving (13⅝ × 20¹¹⁄₁₆ in.). Collection of Nasher Museum of Art at Duke University; Museum Purchase, Von Canon Fund (1974.2.75).

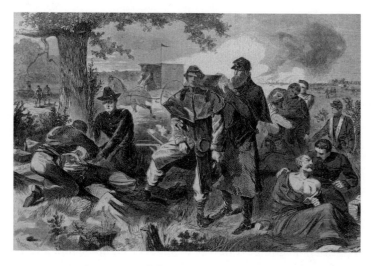

FIGURE 6. Winslow Homer, "The Surgeon at Work in the Rear during an Engagement" in *Harper's Weekly* (July 12, 1862). Wood engraving (9⅛ × 13¾ in.). Collection of Nasher Museum of Art at Duke University; Museum Purchase, Von Canon Fund (1974.2.74).

portrayal of "The Surgeon at Work at the Rear during an Engagement" (Figure 6).[35]

"Winslow went to the front of Yorktown & camped out about two months. He suffered much," his mother wrote to Arthur, and he returned "so changed that his best friends did not know him." By Mrs. Homer's account, he "was without food for 3 days at a time & all in camp either died or were carried away with typhoid fever." Like thousands confronting the shock of war, Homer lost his innocence abruptly and witnessed sights that most never face. Winslow "is well & alright now," Henrietta Homer assured herself and Arthur.[36] But her artistic son may have papered over what we now call posttraumatic stress. Some have explained Homer, the private bachelor of later years,

FIGURE 7. Winslow Homer, "Our Watering Places–The Empty Sleeve at Newport" in *Harper's Weekly* (August 26, 1865). Wood engraving (10⅛ × 15 in.). Collection of Nasher Museum of Art at Duke University; Museum Purchase, Von Canon Fund (1974.2.88).

as a taciturn Yankee or a closeted homosexual. I think it makes equal sense to suggest that shadows of combat remained a lasting part of Homer's life. The haunted face in his wood engraving, "The Empty Sleeve" (Figure 7), suggests Homer's empathy at the end of the war for a veteran who has lost the limb nearest to his heart, and who struggles to rejoin civilian life in New England.

If Homer's encounter with warfare was traumatic, it also spurred personal growth. In a strange way, the Civil War became Homer's Harvard, his higher education. As Nicolai Cikovsky puts it, "the war became his school; more than any other experience, it was instrumental in determining what kind of artist Homer became." It "called upon Homer's powers of

innovation and interpretation in more ways and to a greater degree than more ordinary events and pedagogical procedures would have done." This unprecedented cataclysm, the art scholar continues, exerted "challenging demands on his inventiveness and artistic intelligence." It "fully aroused his consciousness and convictions and made of him a moral and political being."[37]

I would take Cikovsky's point a step further, arguing that much of Homer's moral and political growth in wartime, like Lincoln's, centered upon his expanding consciousness of the grim plight and potential liberation of enslaved black Americans. Things Lincoln only partially grasped before the war, he steadily came to comprehend, embrace, and convey to others over time.[38] The same was true for Homer. Both men ended up not too far from where Frederick Douglass had started out—just as most white Americans in our own era have eventually drawn closer to where Martin Luther King Jr. and other leaders in the civil rights movement began. As Lincoln's growth can be traced in his speeches and letters, Homer's progress can be charted in his art work.

As early as November 1861, in "Songs of the War," Homer juxtaposes Union recruits singing the chorus of "John Brown's Body" with an illustration for the popular tune "Dixie." That view shows one slave toiling in the background while another, the largest figure in the spread, sits on a powder keg marked "Contraband." A month later, in "A Bivouac Fire on the Potomac" (Figure 8), Homer observes northern soldiers watching another contraband, who dances to the fiddle music of an aged black man. Reactions range from fascination to indifference. On the right, two men play cards, and a tiny marker between them reads "I O U." Does this scrap of paper apply only to their

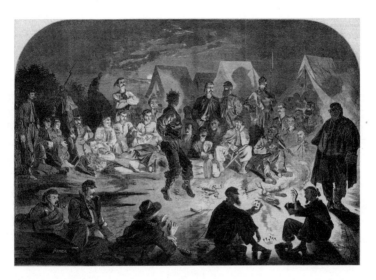

FIGURE 8. Winslow Homer, "A Bivouac Fire on the Potomac" in *Harper's Weekly* (December 21, 1861). Wood engraving (13¾ × 20¼ in.). Collection of Nasher Museum of Art at Duke University; Museum Purchase, Von Canon Fund (1974.2.64).

card game—or to the larger moral and military contest regarding slavery as well? Homer enjoyed inserting small details that might—or might not—have much larger implications.[39]

A stark oil sketch, of uncertain date and origin, shows a side view of a dejected black man seated on the ground, his ankles bound in chains. If authentic, *The Shackled Slave* (1863?) shows Homer coming to terms with the reality of race slavery while also learning the basics of painting black figures.[40] But by far his most important contacts occurred in Union army camps. There he encountered countless contrabands, refugees of all ages from the plantation gulag who were cooking, washing, digging graves, and polishing boots. As *The Bright Side* suggests, Homer

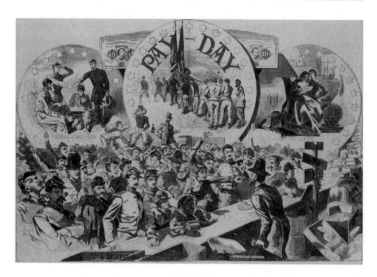

FIGURE 9. Winslow Homer, "Pay-Day in the Army of the Potomac" in *Harper's Weekly* (February 28, 1863). Wood engraving (13⁹⁄₁₆ × 20½ in.). Private collection.

was particularly absorbed by the black teamsters who handled the thousands of horses and mules so vital to the army.

One of Homer's finest spreads for *Harper's*, "Pay-Day" (Figure 9), appeared in February 1863.[41] Three vignettes at the top depict troops receiving wages and sending money home. In the swirling scene below, soldiers spend part of their pay in a rowdy "Descent on the Sutler," making competing demands on the civilian who provides for their basic needs. But this sutler, with his tall hat and bushy beard, is President Lincoln, as contemporaries easily recognized. They also spotted General McClellan in the left foreground, confronting Lincoln just as he did after the Battle of Antietam. Photographs from the previous fall had shown "Little Mac" squared off opposite his commander, days before Lincoln fired him.

But at the center of "Pay-Day" a much larger recent event— Lincoln's Emancipation Proclamation—is also hidden in plain sight, for a black man appears between these two powerful figures. He has worked his way to the front, wearing the symbolic liberty cap of a freed slave, and he forms part of a tight foreground circle. The sutler's open palm points to him across the counter. Clearly, Mr. Lincoln has just handed him a tangible reward, which he already protects and enjoys. A grocer's scale with its long balance beam, just below Lincoln's left hand, forms the bottom of this inner circle. Visually, it connects the sutler to the former slave, and it also provides a veiled reminder of the larger scales of justice. Viewers must weigh for themselves whether the black man has just received more, or less, than he deserves.

"A Shell in Rebel Trenches" (Figure 10) also invokes Emancipation.[42] When it appeared in January 1863, that meaning must have been clear to most readers, since Lincoln had just lobbed a bombshell behind enemy lines by proclaiming freedom for slaves in states still controlled by the Confederacy. The picture foreshadows *Near Andersonville,* since the northern artist places his viewers behind Rebel lines. Moreover, by emphasizing the conscripted slave in the left foreground whose eyes blaze with alarm, Homer presents the scene from a black perspective. As in *Near Andersonville,* he underscores the fact that the aggressive Union war effort, symbolized by the smoke of two distant cannons, could endanger the very persons it intends to liberate.

A famous image from the next year echoes "A Shell in Rebel Trenches." Again, the northern artist locates us behind enemy lines, and again two shots from the distance spell instant danger— for soldier and viewer alike. But what Homer made overt in journal illustrations often became more subtle in his oils, such as

FIGURE 10. Winslow Homer, "A Shell in the Rebel Trenches" in *Harper's Weekly* (January 17, 1863). Wood engraving (9⅛ × 13¹³⁄₁₆ in.). Private collection.

Defiance: Inviting a Shot before Petersburg (1864) (Plate 6). For decades, scholars debated whether the scene even involved the Virginia campaign, but industrious research now shows that this picture, like *Near Andersonville,* came into the possession of someone for whom it had special meaning. Patricia Hills has demonstrated that an early owner had been present in Virginia and was wounded there in June 1864, as Grant was closing in on Petersburg.[43]

Homer apparently revisited the Army of the Potomac at just this time, amid Union plans to seize the crucial rail link below Richmond and force the Confederate capital to surrender. Whether or not he witnessed the early, frustrating stages of the Siege of Petersburg, he knew of the boredom and bravado that became part of the standoff.[44] But Homer and his audience also

knew about the stunning scheme that called for Pennsylvania coal miners to dig a 500-foot tunnel reaching beneath the Rebel works and then insert 8,000 pounds of powder at its end to blow a hole in enemy lines. Homer made good use of this hidden charge, keeping it buried out of sight beneath the painting.

A few history buffs may have read one of the recent books on the calamity known as "The Crater" or seen the debacle reenacted in Hollywood's *Cold Mountain* (2003).[45] But most modern viewers of Homer's painting remain captivated by the drama unfolding above the trenches and miss hints of the explosive charge waiting below. In 1864, on the other hand, Homer's audience knew all about the deadly blast as a major moment in the war. The detonation occurred before dawn on July 30, creating a gaping chasm just as planned. This hole in Southern defenses allowed Union troops, including hundreds of black soldiers, to rush in, only to be trapped in the huge pit and destroyed by Confederate counterattacks. The Battle of the Crater quickly came to symbolize the futility and destructiveness of the endless conflict. Grant called it "the saddest affair I have witnessed in the war."[46]

Surprisingly, major art tomes that explore Homer's Petersburg picture still make no mention of The Crater, even though it caused roughly nine hundred deaths, with thousands more wounded or captured—North and South, white and black. Nor do they discuss the black figure.[47] Yet I still believe, as Karen Dalton and I argued years ago, that this intentionally stereotypic African American provides the key link. As Richard Slotkin has stressed repeatedly, the central debate that swirled around the entire bloody episode concerned the suitable role for blacks in the war.[48] Once again, newspapers and politicians debated the fighting capacities of "colored soldiers" and the

shortcomings of the white officers who had sent so many to their deaths.[49]

Soul-searching within the Union Army became intense and public. "The chances of success were so great," Grant said, and "the failure so utter," that he convened a court of inquiry that deliberated for weeks over this "stupendous failure."[50] And what was to be made of the conduct of Confederate troops? Historian Drew Gilpin Faust quotes a Southern private named Harry Bird remarking that after the battle they "quieted wounded black soldiers begging for water 'by a bayonet thrust.' Bird welcomed the subsequent order 'to kill them all'; it was a command 'well and willingly . . . obeyed.'" Faust joins other scholars in confirming that "violence against black soldiers and their white officers was extensive and widely discussed among northern soldiers and civilians alike."[51]

With public turmoil over The Crater in mind, the painting's overall design, with its emphatic horizon creating an upper and lower world, takes on added meaning. Viewers who knew all about that chaotic episode and its aftermath could sense that the banjo's shaft, the sentry's rifle, the single branch on the left and the glinting bayonets on the right all point toward the underground charge and its devastating consequences, especially for black Americans. Could some specific disaster also lurk behind *Near Andersonville*?

General Stoneman's Raid

. . . even a chance of success will warrant the effort.

On July 30, 1864, Petersburg was not the only place where a daring Union scheme turned into a costly debacle. By strange coincidence, a plan hatched in Georgia by General William Tecum-

seh Sherman and his cavalry officers unraveled on the same day as Grant's misfortune in Virginia. Since late June, Union forces had been frustrated in efforts to seize Atlanta from the north, suffering over eight thousand casualties with little sign of success.[52] But several long-distance raids by Union cavalry had proven effective, so on July 24, the restless commander conceived a two-pronged cavalry assault to cut the city's rail link to Macon, eighty miles to the southeast.

Sherman planned to send mounted forces in wide arcs around the city—Major General George Stoneman circling to the east and Brigadier General Edward McCook moving to the west—for a double attack on the Macon & Western Railroad between Fayetteville and McDonough. The two cavalry columns, totaling more than eight thousand men and horses, would converge on the little station at Lovejoy, twenty-five miles below Atlanta, and destroy the tracks.[53] This seemed ambitious enough, but amid final preparations on July 26, General Stoneman penned a request that took even the aggressive Sherman by surprise.

"At the very moment almost of starting," Sherman wrote later, "General Stoneman addressed me a note asking permission, after fulfilling his orders and breaking the road, to be allowed . . . to proceed to Macon and Andersonville and release our prisoners of war confined at those points."[54] If "I see a good opening," Stoneman proposed, I wish "to make a dash on Macon and by a vigorous stroke release" the Union officers imprisoned there at Camp Oglethorpe, before proceeding on to Andersonville. "I would like to try it," he told Sherman, and "am willing to run any risks. . . . Now is the time to do it. . . . If we accomplish the desired object," he concluded, "I should feel compensated for almost any sacrifice."[55]

"There was something most captivating in the idea," Sherman recalled.[56] "I see many difficulties," he told Stoneman, "but as you say, even a chance of success will warrant the effort, and I consent to it." He made clear that Stoneman was to fulfill his original orders before attempting "to accomplish both or either of the objects named. . . . If you can bring back to the Army any or all of those prisoners of war, it will be an achievement that will entitle you and the men of your command to the love and admiration of the whole country."[57] But in fact, the mission quickly turned into what one scholar has called "the greatest cavalry fiasco of the Civil War."[58]

As with Grant's scheme to blow up Rebel defenses near Petersburg, Sherman's sudden strike involved a risky, unorthodox plan. It sought to end a wearisome impasse and revitalize northern support for the Union war effort. But unlike The Crater, this event has earned very few books, or even paragraphs, from Civil War scholars. In *Battle Cry of Freedom,* historian James McPherson gives the foray seven lines, ending with the comment, "Six hundred of these Yankee troopers did reach Andersonville—as prisoners." A recent book on the Siege of Atlanta states only that Sherman "sent out two cavalry raids to break the railroad to Macon and reach the Andersonville prison; both failed badly."[59]

It makes sense, then, to revisit this forgotten encounter—and to illustrate it with an earlier Homer image from Virginia (Figure 11)—for he knew all about cavalry operations.[60] Though never in Georgia, he clearly thought hard about this debacle from a variety of angles. Such a large maneuver—sending thousands of men and horses deep into enemy territory along two separate routes—would hold high risks, even with lengthy planning. But Sherman gave his exhausted cavalry only forty-eight hours to prepare. He feared Confederate reinforcements,

FIGURE 11. Winslow Homer, "The Union Cavalry and Artillery Starting in Pursuit of the Rebels Up the Yorktown Turnpike" in *Harper's Weekly* (May 17, 1862). Wood engraving (9¼ × 13¾ in.). Collection of Nasher Museum of Art at Duke University; Museum Purchase, Von Canon Fund (1974.2.69).

and he wanted to get a jump on the Confederate cavalry of General Joseph Wheeler.[61] So the hurried venture began before dawn on Wednesday, July 27. "The cavalry has now been out two days," Sherman reported to Washington on Thursday night, "and to-morrow should show the effect. I feel very confident they will reach the Macon road."[62]

Even as Sherman wrote, McCook's men had crossed the Chattahoochee River and swept through the small town of Palmetto. As darkness fell, they torched supply depots, slashed telegraph wires, and burned railroad ties. In Newnan, thirteen miles to the southwest, Kate Cumming recorded, "the whole sky was illuminated by a glare of light, in the direction of Palmetto."[63] McCook's success continued through the night. Pressing east

from Palmetto, his forces overran a huge supply caravan; they took prisoners, destroyed wagons, and bayoneted hundreds of mules. Before dawn they slipped into Fayetteville, capturing three hundred Southern soldiers, and by 7:00 A.M. on July 29, McCook's men had captured another wagon train, crossed the bridge over the Flint River, and arrived, as planned, at Lovejoy Station.

Exhausted, but aware that Confederate counterattacks were in the offing, the troopers laid waste the village. They burned supplies, cut wires, destroyed rolling stock, and bent heated railroad tracks into the unusable shapes known as "Sherman's bowties." Still seeing no sign of Stoneman's force, the weary column of several thousand horsemen began to withdraw back to the west. By noon on July 30, after another twenty-four hours in the saddle, they were skirting the town of Newnan, hoping to re-cross the Chattahoochee before Joe Wheeler's enemy cavalry materialized.

Stoneman, meanwhile, had pushed east and south around Atlanta, eluding Wheeler's horsemen. But he found that a missing bridge stopped his move westward to meet McCook. Disappointed, or perhaps pleased, he left McCook to his own devices and eagerly launched "the dash on Macon" that he had envisioned. On Saturday, July 30, his forces came within sight of the city. But word of Stoneman's attack had preceded him; Macon's leaders had posted defenses outside the city to hold the enemy at bay on the east side of the Ocmulgee River. Stymied, Stoneman would have to press on toward Andersonville, or retreat back toward Atlanta.

By Saturday afternoon, the two Union forces were isolated and exhausted, far behind enemy lines. Out of touch with one another, each was being hounded by Confederate horsemen

familiar with the territory. At Brown's Mill near Newnan, General Wheeler's cavalry caught up with McCook's worn-out column and inflicted a rout. McCook and several hundred others escaped and eventually made their way to Union lines, but most of his men were killed or captured.[64] Summoned to the scene, nurse Fannie Beers recalled the struggles of dying horses and the awful cries as she trudged over a battlefield "slippery with blood." Corpses "lay all around us on every side, singly and in groups and *piles*," Beers recounted. "As we drew near the suffering men, 'Water! water!' was the cry."[65]

Far to the southeast Stoneman, rebuffed at Macon, gambled on returning northward rather than pressing south. "The march that night . . . was very tedious," one officer recalled, with men asleep "upon their horses," after three days "without sleep and with very little food."[66] The next day a division of Wheeler's cavalry, under Brigadier General Alfred Iverson, intercepted Stoneman's force at Sunshine Church, fifteen miles north of Macon. Iverson's fresh forces crushed their tired, confused opponents. As at Brown's Mill the day before, some Union cavalrymen eluded capture to return to Sherman's lines. But Stoneman became the highest ranking officer captured in the entire war, and hundreds of his men were taken prisoner at Sunshine Church.

The Union cavalry columns had traveled so far and suffered such total reversals that Sherman did not learn their fate for days. He had sent out, by his own reckoning, more than eight thousand men and their horses. As survivors straggled back to Union lines, his command had trouble appraising who had been killed, wounded, or captured. But it seems likely that the figure for Union troopers taken prisoner was larger than the six hundred mentioned by historian James McPherson. Stoneman and

the other captured officers were imprisoned at Camp Oglethorpe in Macon, and in September, after Sherman finally took Atlanta, they were released as part of a limited prisoner exchange.[67]

Most of the nonofficers, however, fared less well. As their superiors rode off to Macon under escort, the men were pushed into line by guards. "We were . . . worn out and discouraged," Private John Sammons recalled: "The rebels were in high glee and taunted us in many ways, but we dare not say one word back." The long column of disarmed men, flanked by Confederates on horseback, stopped for the night northeast of Macon. "We went to bed very early," Sammons noted, and "with very heavy hearts."[68]

The next day, the "captured liberators" were marched into Macon. Then, in the midday heat, the first contingent of 442 prisoners was crowded into boxcars for the three-hour journey south to Camp Sumter.[69] Prison officials, who had braced for an attack, treated the newcomers harshly when their train reached Andersonville Station. "Strip them!" Captain Wirz raved. "Take everything away! They are raiders . . . they are all thieves."[70] When McCook's men began arriving on August 3, they received a similar welcome. "More of Stoneman's raiders came in today," one prisoner noted; "they are quite destitute, the Johnnies being especially severe on this class of our troops."[71]

Word of Stoneman's reversal spread slowly through the prison camp, one more piece of discouraging news among men struggling to stay alive. "Very hot," a Massachusetts man wrote in his diary for August 2. "Heavy thunder-storm in the afternoon . . . flooded us all, soaking everything. I am . . . very weak from cough and diarrhea. A lot of prisoners came in, . . . taken at Macon while *en route* for this place to relieve us."[72] A Pennsylvania prisoner noted that Stoneman's cavalry-

men "have been raiding in the vicinity of Macon, and . . . have ended up by visiting the 'bull pen' here." In this place, he added, "they will . . . rest from their labors for some time if not for all time to come."[73]

Indeed, many of the prisoners would never make it home. But rumors of conditions in Andersonville were leaking out, prompting the *New York Times* to editorialize for prisoner exchange.[74] News of setbacks in the field only worsened the dilemma, as the northern press described the failure of Stoneman and McCook. On September 1, a *New York Times* correspondent reported from "near Atlanta" that McCook had commanded "less than three thousand men," and that parties of survivors were returning daily, leaving his losses at "less than a thousand." As for General Stoneman, the reporter conceded it was now clear that "his forces were whipped and captured near Macon." He remarked that around the Union camp in Georgia, the "defeat is productive of much deep feeling."[75]

As the scope of Stoneman's disastrous reversal became apparent, the news produced "much deep feeling" across the North as well, especially when combined with grim details from Virginia about the "stupendous failure" at The Crater. Homer, recently returned from the front, would have understood better than most the pathos surrounding these unlikely Yankee schemes that had gone totally awry. Reading in the papers about the shocking explosion near Petersburg, the artist composed *Inviting a Shot,* one of his best-known wartime oils. Later, he drew on public awareness of Stoneman's doomed raid—the other wrenching fiasco of late July 1864—to shape *Near Andersonville.* But in this case, the painting swiftly disappeared from view for a century, and even the precipitating event slipped into oblivion for generations.

In both pictures, the northern artist takes his viewers behind enemy lines, but there is a striking evolution in his treatment of the black figure. In the 1864 painting set near Petersburg, the emblematic musician seems to be a secondary character, entrenched well below the horizon line and biding his time. (He seems more stereotyped than the wistful banjo player in Johnson's *Negro Life at the South*.) In contrast, the picture completed in 1866 and set near Andersonville replaces the small and minstrel-like black man sitting in the shadows with an erect and imposing black woman, standing alone in the foreground.

The contrast with *Prisoners from the Front*, painted at the same time, is even more striking. Homer could have repeated and inverted that successful formula by creating another all-white captivity narrative: a tableau of Stoneman surrendering to his captors, or perhaps a close-up of haggard Union prisoners confronting a Confederate officer. But in *Near Andersonville* the uniformed combatants are not arrayed in opposition across the foreground. Instead, they are intermingled and diminished in size, squeezed together at the edge of the painting.

This commingling of blue and gray in the distance gives visual meaning to the black perspective that Frederick Douglass expressed in 1865. Speaking in Boston, he commented candidly that for much of the Civil War the contending sides, viewed from the slave perspective, seemed far more similar than most whites could concede. When the war began, Douglass emphasized, "The South was fighting to take slavery out of the Union, and the North fighting to keep it in the Union; the South fighting to get it beyond the limits of the United States Constitution, and the North fighting for the old guarantees—both despising the Negro, both insulting the Negro."

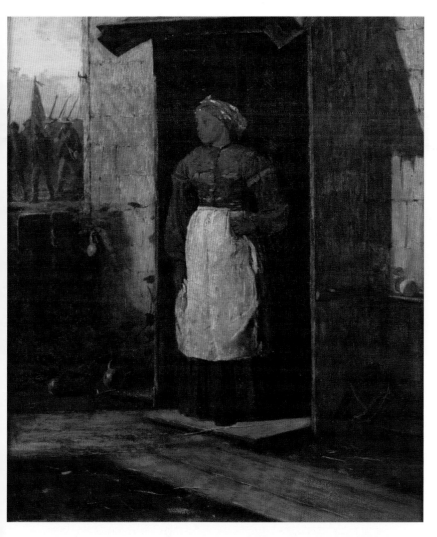

PLATE I. Winslow Homer (1836–1910), *Near Andersonville*, 1865–1866. Oil on canvas, 23 x 18 in. Gift of Mrs. Hannah Corbin Carter, Horace K. Corbin, Jr., Robert S. Corbin, William O. Corbin, and Mrs. Clementine Corbin Day in memory of their parents, Hannah Stockton Corbin and Horace Kellogg Corbin, 1966. Collection of the Newark Museum (66.354).

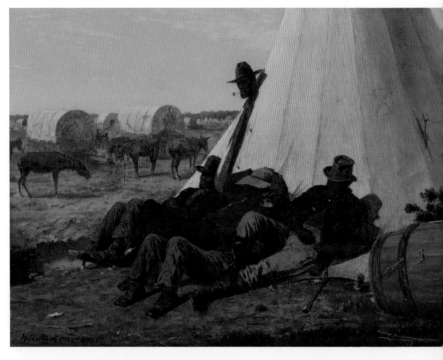

PLATE 2. Winslow Homer, *The Bright Side,* 1865. Oil on canvas, 32.4 x 43.2 cm (12¾ x 17 in.). Fine Arts Museums of San Francisco. Gift of Mr. and Mrs. John D. Rockefeller III (1979.7.56).

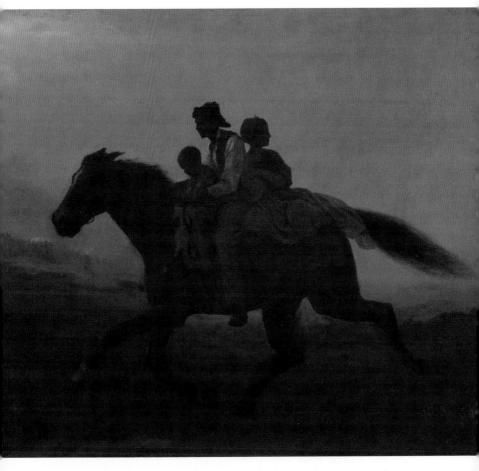

PLATE 3. Eastman Johnson (American, 1824–1906), *A Ride for Liberty—The Fugitive Slaves* (ca. 1862). Oil on paper board, 21¹⁵/₁₆ x 26⅛ in. (55.8 x 66.6 cm). Brooklyn Museum (40.59). Gift of Gwendolyn O. L. Conkling.

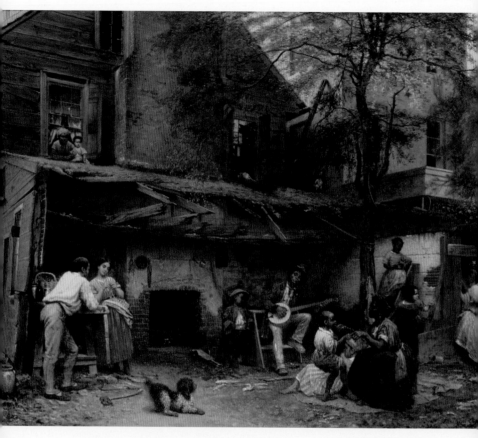

PLATE 4. Eastman Johnson, *Negro Life at the South,* 1859. Oil on canvas, 36 x 45¼ in.; accession no. S-225. Robert L. Stuart Collection on permanent loan from the NYPL. New-York Historical Society.

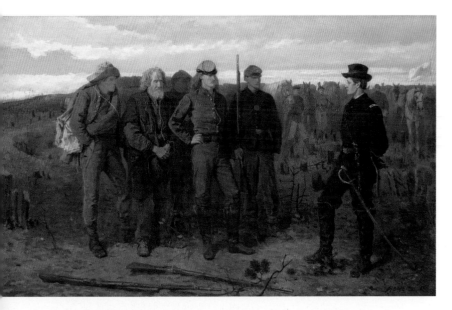

PLATE 5. Winslow Homer, *Prisoners from the Front*, 1866. Oil on canvas, 24 x 38 in. (61 x 96.5 cm). Gift of Mrs. Frank B. Porter, 1922 (22.207). The Metropolitan Museum of Art, New York, NY, U.S.A. Image copyright © The Metropolitan Museum of Art / Art Resource, NY.

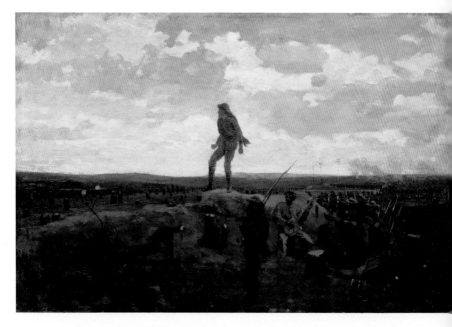

PLATE 6. Winslow Homer, *Defiance: Inviting a Shot before Petersburg, Virginia,* 1864. Oil on panel, 12 x 18 in. The Detroit Institute of Arts, U.S.A. Founders Society purchase and Dexter M. Ferry Jr. fund / The Bridgeman Art Library.

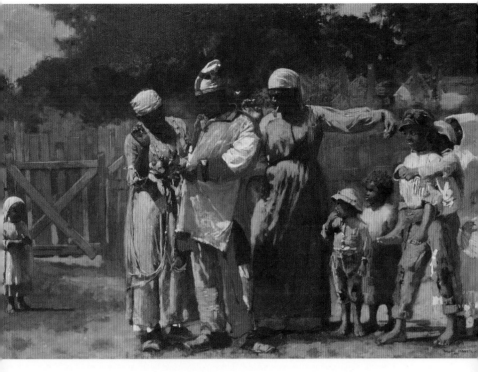

PLATE 7. Winslow Homer, *Dressing for the Carnival*, 1877. Oil on canvas, 20 x 30 in. (50.8 x 76.2 cm). Amelia B. Lazarus Fund, 1922 (22.220). The Metropolitan Museum of Art, New York, NY, U.S.A. Image copyright © The Metropolitan Museum of Art / Art Resource, NY.

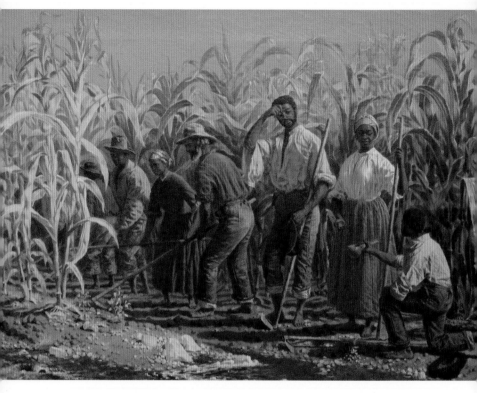

PLATE 8. Thomas Waterman Wood (1823–1903), *A Southern Cornfield, Nashville, Tenn.*, 1861. Oil on canvas, 28 x 40 in. (71.1 x 101.6 cm). T. W. Wood Gallery and Art Center, Montpelier, VT.

W. E. B. Du Bois quoted this passage in his powerful study, *Black Reconstruction.* Therefore, he added, it was "at first by no means clear to most of the four million Negroes in slavery what this war might mean for them." He could have been describing the woman in Homer's painting, still enslaved near Andersonville in the summer of 1864. Such people, Du Bois explained, "moved silently," biding their time and adopting a conscious posture of "listening, hoping, hesitating."[76] It was a wise and necessary response to a situation of overwhelming uncertainty. Any misstep spelled trouble, since moments of life-changing promise could suddenly warp into days and years of heightened danger and duress.

What happens, Douglass and Du Bois are asking, if any part of the Civil War drama is viewed explicitly from the vantage point of the enslaved? In *Near Andersonville,* Homer may go further than any American artist ever had in exploring that question. So it is time to move from the background to the foreground, concentrating at last on the woman in the sunlight and on everything that surrounds her.

CHAPTER 3

THE WOMAN IN THE SUNLIGHT

Standing at a Fork in the Road
. . . a fortnight that has had no equal in the political history
of the American republic.

Near Andersonville, completed early in 1866 just as the artist
turned thirty, addresses recent events head-on. Set in south-
west Georgia in the late summer of 1864, it weighs the human
cost of what then seemed an endless war. The painting speaks
to the national debate, escalating during that year, that weighed
mounting war deaths alongside ongoing race slavery. For the
initial viewers of Homer's picture in April 1866—including Sarah
Kellogg, the painting's first owner—this agonizing dilemma
remained very recent and familiar history.[1] Homer's picture,
by dealing with controversial current events, resembles more
famous nineteenth-century works, such as Théodore Géricault's
Raft of the Medusa and Édouard Manet's *Execution of Maximilian.*[2]
Like those two great French paintings, *Near Andersonville* is a
contemporary picture of enduring interest.

Entering the foreground of Homer's painting, it makes sense
to concentrate first on the structures that surround the central
figure, since the rude and unusual setting—the house, the door-
way, the sill, and the walkways—are laced with meaning. Then
we shall turn to the woman herself, in order to get closer to what
she is thinking and feeling. Perhaps such suggestive details as the
gourds, the kerchief, the dress, and the apron can even give us
hints as to her possible past and future. Finally, after examining

what the picture might have meant for the artist and his generation, we can step back to consider the possible broader meanings of this anonymous woman for today's very different world.

The largest portion of the painting is not the military scene or the foreground figure; it is the building that surrounds her. This element is also the most ambiguous—in a picture that contains layers of ambiguity. Are we looking at the front of the woman's small home, or at a plantation outbuilding, or at the back corner of a white-owned mansion? Homer does not show a rough-hewn slave cabin, such as the dwelling of notched logs he sketched in Virginia in 1862.[3] Instead, he creates a nondescript building that could be the larger symbolic house I have invoked before. Maybe the pale sun is finally falling on the south side of Lincoln's archetypal House Divided.

Whatever we make of the house itself, the well-crafted doorway is elaborate and complete, creating a frame within the frame. The wooden side panels that block out summer sun and winter wind create a private and sheltering place. But they also give off contradictory hints, suggesting a very small stage, or perhaps a very large coffin. In artistic terms, the dense interior blackness highlights the head of the central figure, much as the vivid blue sky in *The Bright Side* (Plate 2) offers a contrasting background for the face and hat of the pipe-smoking teamster.

But Homer's complex doorway has a larger use. The woman emerges from unfathomable darkness—the long nighttime of slavery. A small shadow extending back from her feet implies she is still shackled to that dark, confining space. At the same time, she has stepped forward into the sunlight, eluding the shade from the overhanging roof. Not surprisingly for a picture completed at the start of Reconstruction, Homer's black Georgian stands—both literally and figuratively—on a

threshold. She faces, and epitomizes, a transition between two very different worlds. In nineteenth-century representations of women, the doorway was an important space, since it marked the intersection between male and female spheres of influence. American artists often showed women on the doorstep, working or resting, welcoming people or bidding husbands and children goodbye.[4]

For example, Homer's 1870 engraving, "The Dinner Horn" (Figure 12), shows a confident farm woman on the back stoop summoning men from the field.[5] Unlike the Georgia scene, this farmhouse has an open window, a purring cat, a kettle on the fire, and a table set for dinner. Granted, Homer again puts the men in the distance and draws containers and vines beside the door. But one other difference is the small metal scraper, placed beside the New England doorway so people can clean the mud from their shoes. The enslaved Georgian has no such device; instead, she stands on a traditional mud-sill.

The term "mud-sill" is hardly familiar today, but students of African-American history and antebellum culture recall that in 1858 South Carolina's pro-slavery senator, James Henry Hammond, propounded his infamous "Mud-sill Theory." "In all social systems there must be a class to do the menial duties," Hammond claimed, in order to free others (like himself) to pursue lives of "civilization and refinement." This lowest class constituted the essential "mud-sill of society," the slave owner asserted during a speech on the Senate floor. According to Hammond, slavery was a necessary and positive good: "you might as well attempt to build a house in the air as to" construct a culture "except on this mud-sill."[6]

The term became controversial in 1859, when Lincoln attacked Hammond's mud-sill concept head-on, arguing that in

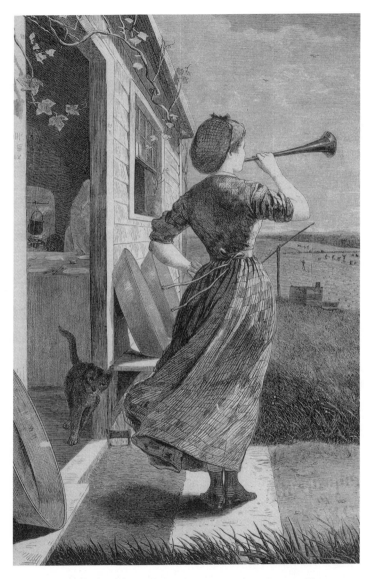

FIGURE 12. Winslow Homer, "The Dinner Horn" in *Harper's Weekly* (June 11, 1870). Wood engraving (13⅞ × 9 in.). Collection of Nasher Museum of Art at Duke University; Museum Purchase, Von Canon Fund (1974.2.142).

the North no workers were "fatally fixed" on the bottom rung of the social ladder.[7] After Lincoln's election, Homer drew Hammond's likeness from a photograph and included him in a group portrait of South Carolina's seceding delegation.[8] Hammond's "mud-sill" remained a loaded phrase throughout the war years, and in *Near Andersonville,* Homer seems to challenge the former South Carolina governor directly. The artist uses his brush to refute Hammond's notion that blacks were no more than a perpetual mud-sill, "eminently qualified" by "Nature's law" to forever do only "menial duties" that required "a low order of intellect and but little skill."[9]

From our distant vantage point, this mud-sill reference may already seem a considerable leap. But we can take a further step from the mud-sill to the puzzling and incongruous board pathways, heading in opposite directions at the bottom of the painting. The woman not only stands at a threshold; she confronts a fork, a place where two roads diverge. Think of Robert Frost—a later but similar New England artist—and recall his poem, "The Road Not Taken." The poet recounts how long he stands before two comparable and competing paths, aware that he will never be in this position again. The choice, Frost reflects, will make "all the difference" in life's future course.[10]

In *Near Andersonville,* the divided path suggests the difference between ongoing enslavement and liberation by Stoneman's cavalry. It also reminds viewers that slaves lived on the horns of a dilemma—to stay put or to risk escape.[11] But given Homer's political awareness, honed at *Harper's Weekly,* perhaps the boards had more immediate relevance as well. They called to mind the long, desperate summer of 1864 and the most crucial presidential race in American history. How? Because specific *planks* in the contrasting party *platforms* were at the epicenter of the

campaign debate. It would be hard to exaggerate their importance, both politically and visually.

In June the Republicans, despite deep divisions, nominated Lincoln for a second term. Their Baltimore platform called for "unconditional surrender." When a plank was put forth demanding a constitutional amendment to abolish slavery, "delegates sprang to their feet . . . in prolonged cheering."[12] But July brought new pressures. Confederate forces under General Jubal Early brazenly attacked Washington, and their daring raid came within five miles of the White House. In Congress, radicals challenged Lincoln's plans for a moderate postwar Reconstruction. And at Niagara Falls, the influential newspaper editor, Horace Greeley, was pushing for secret peace negotiations with representatives of Jefferson Davis.

Meanwhile, the Union war effort, with Grant in Virginia and Sherman in Georgia, had bogged down badly. Neither Richmond nor Atlanta had fallen, but federal losses during May and June amounted to a staggering ninety thousand soldiers.[13] "I fear the blood and treasure spent on this summer's campaign have done little for the country," George Templeton Strong wrote in his diary. By mid-July, even the citizens supporting the war appeared "discouraged, weary, and faint-hearted," Strong noted. "They ask plaintively, 'Why don't Grant and Sherman do something?'"[14]

On July 18, the president himself did something, issuing two controversial documents. The first was a memorandum labeled "To Whom it May Concern" that expanded the promise of the Emancipation Proclamation. It detailed to Greeley that any Confederate peace proposal had to assure "the integrity of the whole Union, *and the abandonment of slavery.*" By insisting so emphatically on total emancipation, the president "raised a new and

potentially fatal factor in his re-election equation," writes historian David Long in his detailed recent study of the campaign.[15]

That same day, Lincoln made his political situation even worse: he issued a call for five hundred thousand new enlistments, adding the unpopular proviso that a draft would make up any shortfall after seven weeks (Figure 13). The army desperately needed fresh troops, and the only eager volunteers were African Americans, most of them former slaves. They were quickly proving themselves in battle to a skeptical white public. But they had high expectations, demanding equal pay and assurances that the government would stand up for the rights of black soldiers taken prisoner. This in turn antagonized many

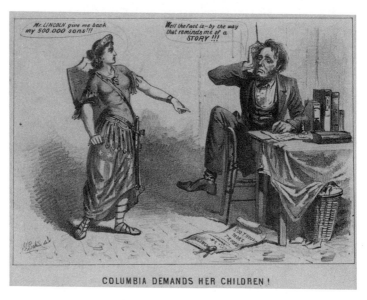

FIGURE 13. Joseph E. Baker, *Columbia Demands Her Children!* 1864. Lithograph. Library of Congress, Washington, DC.

"Copperheads," the antiwar Democrats who mocked Lincoln as a radical abolitionist.[16]

Confederate resistance around Atlanta and the debacle at The Crater worsened the Republican outlook further. "In early August," writes historian John Stauffer, "Lincoln looked like a man defeated;" the haggard president "confided to friends, 'I am going to be beaten, and unless some great change takes place *badly* beaten.'"[17] Still, the president continued to believe that, despite the ongoing war, the fall election must go forward as mandated by the Constitution, whatever the outcome.[18]

Boxed in, Lincoln and his party were forced to consider the consequences of a Republican defeat. If war-weary Northern voters proved unwilling to expend further "blood and treasure" toward preserving the Union and gave victory to the Democrats, then the Confederacy would win independence quickly.[19] Or perhaps McClellan, the presumed Democratic candidate, would compromise with the South and allow the secession states to rejoin the Union on their own terms. Either way, plans for ending race slavery would die on the vine, and Southern planters would again enforce lawful enslavement.

The implications for those still in bondage were enormous. Previously, they had worried about the dangers of trying to escape too soon. Now, what if they waited too long? The next chance to depart might be the last. During the American Revolution, many black families had gambled that the war would bring liberty to their doorstep if they stayed put. They had paid dearly across four generations for making the wrong bet. Now it appeared their descendants could be cursed to remain in slavery indefinitely if they did not reach Union lines soon.

On August 19 the president, who knew a defeat at the polls appeared inevitable, invited Frederick Douglass to the White

House and pressed the black leader to take on an important secret task. "The slaves are not coming so rapidly and so numerously to us as I had hoped," Lincoln told his guest. "I want you to set about devising some means . . . for bringing them into our lines." Sensing a victory by his Democratic rivals in the impending fall election, Lincoln feared that only those slaves who could quickly get *"within our lines would be free after the war is over."*[20] Douglass set to work on ways to send black scouts behind enemy lines, but little came of the scheme; it was swept aside by swift and seismic changes in the political landscape.

All this brings us back to the heightened importance of planks, for at the end of August the tables turned dramatically. "It was a fortnight that has had no equal in the political history of the American republic," writes David Long. "The last week of August and the first week of September 1864 brought a remarkable shift in voter mood as the divided Republican Party closed ranks . . . while the Democrats descended into bickering and strife."[21] Early on September 3, Sherman sent a triumphant telegram to Washington confirming his success in Georgia. "Atlanta is ours," he announced, "and fairly won."[22]

At the same time, equally stunning news came out of the Democratic convention in Chicago. As expected, party delegates named General McClellan to be their candidate. But they also approved a platform that, given the latest Federal victories, seemed almost treasonous. One plank called for negotiating an immediate end to hostilities. Another, using coded language for maintaining racial slavery, promised "to preserve" the "rights of the states unimpaired."[23] Political printmakers and newspaper cartoonists responded vigorously. Thomas Nast drew an elaborate and scathing critique called

"The Chicago Platform." His vivid dissection of the specific planks—word by word—helped tip popular opinion to the Republicans.[24]

In their fine book on popular prints in the Civil War North, Mark Neely and Harold Holzer devote a whole chapter to "The 1864 Presidential Campaign in the Graphic Arts." They note that artists created "witty, but often cruel lampoons that . . . fell into three distinct categories."[25] On one hand, Republican cartoonists mocked McClellan's war record, while on the other, Democratic satirists fanned racial fears, coining the derogatory new term "miscegenation."[26] But the third and most important category involved "comparisons between the Republican and Democratic platforms" often dramatizing the contrast "in two separate images, side by side, on a single sheet."[27]

Neely and Holzer find that a "favorite artistic weapon in the printmakers' arsenal was the Democratic platform itself, which was invariably depicted literally—as a pile of rotten wood pieced together to make a rickety platform." Republicans "fought hard to keep McClellan tied to the peace plank, and printmakers fed off the issue imaginatively, making ramshackle wooden platforms a key emblem of their cartoons." One Currier and Ives print, *The Chicago Platform and Candidate* (Figure 14), shows a two-faced McClellan balancing on a wobbly Democratic platform. He is supported by "Jeff" Davis, "Jeff's Friend" (the Devil himself), and two leading Copperheads. A soldier calls from the left, "It's no use General! You can't stand on that platform!" In the 1860 campaign, fence rails had emerged as a controversial visual symbol, when friend and foe cast candidate Lincoln as a backwoods rail-splitter. In 1864, it was the party platforms, with their contrasting planks, that took—and sometimes became—center stage.[28]

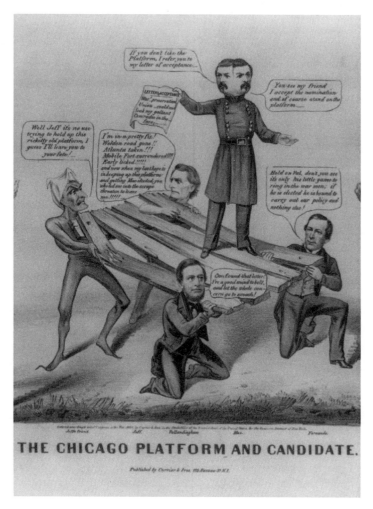

FIGURE 14. Currier & Ives, *The Chicago Platform and Candidate*, 1864 (Detail). Lithograph. Library of Congress, Washington, DC.

For ten years—his entire working life—Homer had been rubbing shoulders with the nation's best lithographers and cartoonists, learning from, and competing with, the finest newspaper artists of his generation. His *Harper's* colleague, Thomas Nast, was well on his way to becoming the father of the hard-hitting political cartoon. Homer, in contrast, bent his career in a different direction, but he did not give up covert references as he mastered oil painting. Instead, even as he took aim at a new clientele, he retained this technique. So in *Near Andersonville*, one platform in the foreground leads directly to the black woman, and a thin piece of straw at her feet even links her to this pathway. In contrast, the opposing set of "planks" never reaches her threshold, but points instead toward the victorious Confederate flag in the distance.

Hagar in the Wilderness
. . . the Lord hath heard thy affliction.

"At almost the beginning of his career as a painter," Nicolai Cikovsky writes, "Homer had the intention and the intelligence to speak in a pictorially symbolic language. . . . Homer's capacity, at the threshold of his career, to invent symbols and to manipulate complicated symbolic meanings, and to engage with the events and culture of his time, signifies the operation of an acutely keen consciousness, and in its ideological and political dimensions, a developed conscience as well. Any account of his artistic mentality and practice must reckon with them," Cikovsky concludes, "all the more as it has not been customary to regard Homer's intellectual and moral equipment as significant aspects of his artistic enterprise."[29]

Homer's double meanings became more subtle over time,

in keeping with traditional iconography in oil painting. But the same man who embedded rope and sugar cane and flying fish in *The Gulf Stream* (1899) was already making conscious references to mud-sills and planks in *Near Andersonville*, at the beginning of his career.[30] As we move from the edge of the picture toward its center, we are drawn to the face of the solitary figure. We are struck first by the woman's steady gaze and bright kerchief, even before taking in the dark dress, the white apron, and the distinctive gourds on either side of the doorway.

Let's begin with her gaze. At *Harper's Weekly,* Homer had learned a common device for leading his audience into a picture: catch the viewers' eye with foreground figures whose attention, in turn, seems preoccupied by something farther away. In "A Shell in Rebel Trenches" from January 1863 (Figure 10), the startled eyes of the strong black figure on the left direct us toward two white puffs of cannon smoke in the distance. In "The Approach of the British Pirate 'Alabama'," published three months later, figures on deck use a spy glass to observe the blockade runner on the horizon.[31]

Homer continued the technique throughout his career, often taking the vantage point of a child watching adult observers, as in "Dad's Coming!" or "The Battle of Bunker Hill."[32] The device recurs in many of his ocean paintings, such as *The Fog Warning* (1885). The gaze of the central figure leads us into the picture, but it also takes us inside that person's head. We calculate, with the lonely sailor on the Grand Banks, whether he can row his fishing dory to the distant mother ship before it is enveloped in the ominous blanket of fog looming on the horizon.

Several of Homer's wartime studies, completed before *Near Andersonville*, draw us into an individual's thoughts. *The Initials*

(1864) shows the reverie of a well-dressed New England woman as she contemplates the endearing marks carved on a tree trunk by a loved one away in the war. In *Trooper Meditating beside a Grave* (1865), we share the thoughts of a soldier reflecting on a recent loss. In *The Veteran in a New Field* (1865), even though we stand behind the farmer with his scythe, we are gathered into the somber reflections of an ex-soldier who has been spared on the battlefield by the Grim Reaper.

But Homer ventures further in *Near Andersonville*, completed a few months later. If his viewers can go inside the heads of white veterans and their sweethearts, they can also enter into the thoughts of enslaved blacks. This was a radical assertion for mainstream America. Homer was reacting to derogatory images that denied or belittled the mental capacities of all African Americans—and of enslaved women in particular. In one *Harper's* caricature, an obtuse black "mammy" blurts out to Union soldiers, "Oh! I'se so glad you is come." An image from early 1865 (Figure 15) may have sparked Homer's visual rebuttal. It shows a wide-eyed slave woman asking, "Is All Dem Yankees Dat's Passing?"[33] With its somber tone, *Near Andersonville* explicitly refutes this dismissive parody.

In contrast to such insensible and uncomprehending stock characters, Homer's African-American women seem thoughtful and strong. Following a visit to Virginia at the end of Reconstruction, he produced *Dressing for the Carnival* (1877) (Plate 7). There, just as in *Near Andersonville*, a closed fence suggests the division between black and white worlds. In other oils from the end of Reconstruction—such as *The Cotton Pickers* (1876), *A Visit from the Old Mistress* (1876), or *Sunday Morning in Virginia* (1877)—Homer's impressive black females of all ages are absorbed in active thought.[34]

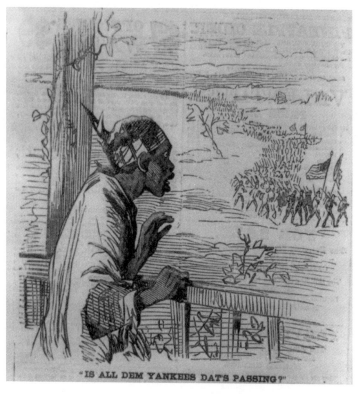

"IS ALL DEM YANKEES DAT'S PASSING?"

FIGURE 15. Unknown artist, "Is All Dem Yankees Dat's Passing?" in *Harper's Weekly* (January 7, 1865). Library of Congress, Washington, DC.

But what is going on inside the Georgia woman's head? Her red, white and blue head scarf offers a clue, for it links her to famous freedom struggles on both sides of the Atlantic. In its color, size, and placement on the canvas, this cloth balances the Confederate flag in the distance, yet ideologically it is an

opposite, mirror image. At one level, this garb is common attire, drawing upon an African heritage. But viewed from another perspective, it ties her to powerful movements in Atlantic history, and to an enduring icon in European and American art. While she is undoubtedly making do with a piece of handed-down material, it is not the black-mammy bandana of popular cartoons. Instead, this bandana hints at what is known as the Phrygian freedom cap.

For ancient Greeks, the soft, conical hat represented the attire of "barbarians" from Phrygia in Anatolia. For the Romans, it came to imply Liberty, and they linked it to the felt cap worn by manumitted slaves. Later, when revolutionary France invoked classical imagery, the Goddess of Liberty often wore such a red cap. After revolutionaries abolished slavery and the slave trade, French artists responded with images of blacks in liberty caps, over the inscription, "I am equal to you; I too am free."[35] "Columbia," the female embodiment of American freedom, usually wore such a cap, so Homer grew up with this iconography. From the time he was small, "Seated Liberty," with her cap on a pole, appeared on virtually every silver coin of the United States.[36]

During expansion of the U.S. Capitol Building in the 1850s, a statue of Freedom, wearing a Phrygian cap, was to stand atop the new dome. But Senator Jefferson Davis of Mississippi successfully opposed the idea, knowing that the cap was the Roman emblem for a manumitted slave.[37] If Homer knew of that public debate, he also must have seen—and reacted against—a crass cartoon aimed at Lincoln and Republican abolitionists during the 1864 campaign. Produced in Boston, *Northern Coat of Arms* (Figure 16) is a disparaging sketch of an oversized Phrygian cap, marked "Liberty," draped incongruously over a huge pair of

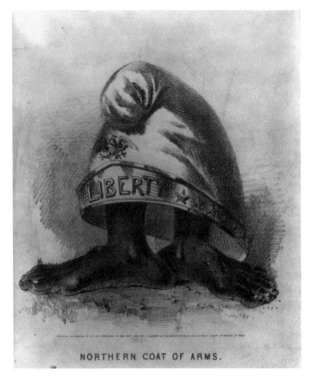

NORTHERN COAT OF ARMS.

FIGURE 16. Joseph E. Baker (uncertain), *Northern Coat of Arms,* 1864. Lithograph. Library of Congress, Washington, DC.

splayed black feet.[38] Again, we must wonder whether Homer is inverting a crude parody. If his own figure wears a freedom cap, it fits her well; she is not blinded or overwhelmed by the thought of liberty.[39]

Other elements close to Homer's woman also suggest thoughts of freedom. One, surprisingly, may be her dark garment. The artist could dress her in long sleeves, even on a hot day, simply to suggest propriety, to confer house-servant status,

or to echo actual photographs from the South. But he may wish to suggest the front-buttoned "Garibaldi blouse" with its distinctive sleeves that was popular at the time. The slave herself would not know about Italy's famous freedom fighter, but Homer's audience was well aware of Giuseppe Garibaldi (1807–1882).[40] In 1861, Thomas Nast covered Garibaldi's triumphs in Italy and helped him gain a wide English-speaking following. It soon became fashionable (especially after "the hero of two worlds" visited Britain in 1863) for women to wear full "Garibaldi sleeves," gathered near the shoulders to imitate the uniforms worn by his "redshirts." The fashion-conscious Homer may be invoking the international hero who had supposedly urged Lincoln, in 1862, to make the Civil War a conflict to end slavery.[41]

A separate reference to the idea of freedom comes from the lowly but meaningful gourds beside the doorway. We know, first of all, that gourds did in fact grow "near Andersonville." Late in 1865, the *New York Times* sent a writer to visit that "Godforsaken place." In an article Homer may have seen, the reporter mentioned gourds specifically as one of the few "spontaneous productions" in the area's sandy soil.[42] We also know that Homer often emphasized the closeness of blacks to the natural world, linking them to emblematic flora and fauna. Elsewhere, I have written about the symbolism of sharks, sugar cane, and flying fish in Homer's *Gulf Stream;* Karen Dalton and I have explored his use of cotton, sunflowers, watermelons, mules, butterflies— even honey bees—in his dignifying images of blacks.[43] Gourds can surely be added to this list.

The gourd was pervasive in West African cultures, and knowledge of its many uses traveled across the Atlantic via the Middle Passage.[44] Informed Americans once understood that gourds held an important place in African-American life and

thought. Thomas Jefferson, for example, pointed out that black slaves introduced the gourd-bodied southern instrument known as the banjo "which they brought hither from Africa."[45] Growing up in New England, Homer probably saw few actual gourds until he visited Virginia, but through the abolition movement he knew that gourds had special meaning in the black struggle for freedom.

Southern workers who managed to flee from bondage often used the Big Dipper to locate the North Star and steer a course north toward freedom. But in the South, as in Africa, blacks made household dippers from gourds. So refugees escaping out of Mississippi and heading north along the Tombigbee River via the Underground Railroad learned their directions through a song about the Big Dipper called "Follow the Drinking Gourd."[46]

An allusion to that song may be hidden in a painting by Thomas Waterman Wood—a Vermont native living in Tennessee at the time of Secession (Plate 8). The figures hoeing corn in *A Southern Cornfield, Nashville, Tenn.* (1861), like blacks in slave labor camps throughout the South, face a persistent choice. Should they continue to endure enslavement, or should those most able, such as the strong young couple on the right, risk slipping away to the North? A youth presents a gourd dipper to this thoughtful pair—and his kneeling pose hints that he may be offering more than a simple drink of water. To the left, younger workers disappear mysteriously into the thick corn, as if stealing away to "follow the drinking gourd."[47]

In *Near Andersonville,* the woman's hopes of freedom hang by a thread, just as the gourd vine clings to—or reaches toward—a slender strand of twine that dangles from a hook between her and the passing soldiers. Like the drinking gourd in Wood's *Southern Cornfield,* Homer's dipper gourds suggest thoughts of

liberation. But gourds have a more universal meaning as well. In art around the world, gourds are a long-standing emblem of fecundity, since they expand rapidly and are filled with seeds.[48] So we must look one more time at the ripening gourds and the woman who is growing them. I shall call her Hagar, partly because that name was used frequently in the South for enslaved females, but mostly because it draws us back to a relevant story in Genesis.

If Hagar fills the middle foreground of the picture, her womb, highlighted by the white apron, occupies the center point. This is not by chance, especially given the proximity of gourds; the two highest ones bracket her hips, echoing the hands that frame her lower stomach. Arrayed about Hagar like the brown faces of absent children, the gourds imply the possible fertility of this woman of childbearing age. If her right hand clenches the apron in response to the military drama unfolding around her, the left hand presses distinctively against her lower frame. Could this be the characteristic gesture of a woman feeling for the first movements of a child within?

If the woman in *Near Andersonville* is in the early stages of pregnancy, this adds a whole new dimension to her thoughts—and to ours. "Not possible," you might say after first eyeing the picture. But a plausible case can, in fact, be made.[49] What initially seems a far-fetched reading takes on a persuasive logic in the context of the ideological battles over race slavery. For decades, abolitionists had dramatized the injustice of enslaved women forced to bear the children of white Southerners. On a different note, supporters of Emancipation and advocates for the Thirteenth Amendment (the prohibition of slavery that became law in December 1865) regularly discussed these momentous changes as representing a *"new birth* of freedom."

In this light, the apron itself demands renewed scrutiny. One rumple may come from Hagar's lowered right hand, but it is harder to explain the pronounced wrinkle on the right side, below her resting left hand. This fold defies gravity to form an enclosing parenthesis and add an unexpected curve. A less obvious and equally inexplicable line creases the apron slightly from bottom to top, bending gently as it reaches her torso. If these folds in the apron seem subtle, the same cannot be said for its color. The garment that wraps around her lower body stands out abruptly in a picture composed almost entirely in shades of brown.[50] Moreover, there is a progression upward from the white apron to the black dress to Hagar's handsome light-brown face. Just as her garb is half black and half white, her ancestry may well involve a mixture of races stretching back over generations, a fact that had powerful meanings for all those opposed to slavery.

This visual equation—white plus black equals brown—has been an enduring obsession through most of American history, but it had special weight in the mid-nineteenth century. In his study of interracial themes in literature, Verner Sollors shows that lurid novels of the era, drawing on familiar and troubling examples, stressed the abuse of power where masters fathered children with enslaved servants and then repeated the act upon their own mulatto daughters. In such a dysfunctional plantation realm, paternity could often be uncertain or kept secret. Therefore, as anxious readers learned, a brother might unknowingly marry his own sister, or a woman might bear her father's child. Crossing racial barriers, in other words, led quickly to plantation incest, and Sollors demonstrates that this shocking "thematic cluster" (miscegenation plus incest) helped authors arouse an offended public in "the struggle against slavery."[51]

Novelist Richard Hildreth exploited this cluster in his popular tale *The Slave* (1836), reprinted in 1856. Two years later,

Lydia Maria Child raised the specter of interracial father–
daughter incest in *The Stars and Stripes* (1858), a melodrama about
escaping from slavery. That same year a best-selling author re-
siding in Cambridge, Mary Andrews Denison, published "a re-
markable exemplar of anti-slavery fiction" entitled *Old Hepsy*
(1858). According to Sollors, "Denison's intricate family saga with
its recurrence of miscegenation and incest" served as "a national
allegory of sorts."[52] Given this literary climate, it is not surpris-
ing that the Old Testament story of Hagar received a sympa-
thetic reading in antislavery circles. For example, Nathaniel
Parker Willis (the publishing impresario who employed Harriet
Jacobs after she escaped from slavery) composed a poem entitled
"Hagar in the Wilderness."[53]

But who exactly was Hagar? In Genesis, the biblical Hagar is
an African-born servant owned by Sarah, wife of the Hebrew
patriarch, Abraham. Sarah, seemingly barren, urges her aged
husband to sleep with Hagar, and improbably the two conceive
a child. Then Sarah, turning jealous and irate over this outcome,
abuses Hagar so much that the slave is forced to flee.[54] Later,
"the angel of the Lord found her by a fountain of water in the
wilderness. . . . And he said, Hagar, Sarah's maid, whence cam-
est thou? And wither wilt thou go?" He tells her, "Behold, thou
art with child, and shall bear a son, and shall call him Ishmael,
because the Lord hath heard thy affliction." "Thou God seest
me," Hagar exclaims in disbelief. Then she accepts divine in-
struction to return to servitude and raise her child, under-
standing that though his life will be troubled, his family will
grow and multiply.[55]

Since slavery times, the "African-American community has
taken Hagar's story unto itself," writes theologian Delores Wil-
liams. "Hagar has 'spoken' to generation after generation of
black women because her story has been validated as true by

suffering black people."[56] "Enslaved, raped, but seen by God, Hagar has been a cherished biblical character in African-American communities," confirms scholar Susanne Scholz. "The story of Hagar demonstrates that survival is possible even under harshest conditions" and even after "the divine messenger sends the woman back to the house of the enslaver."[57] Homer's Hagar could well be carrying her master's child (perhaps even the child of her own father) while also being rebuked by her mistress. Scorned in her "home" but unable to survive in the war-torn Georgia wilderness, she is caught between staying put or taking flight, wrestling with thoughts of an unbearable past and an unknowable future.

An Enduring Presence

Each generation . . . makes its own demands upon art.

It is rewarding to delve into what *Near Andersonville* could have meant to nineteenth-century viewers. Lost meanings are worth recovering and debating. But the importance of Homer's painting does not hinge on the Hagar hypothesis, nor on the significance of the planks or the mud-sill. From its creation, the distinctive picture had a depth that exceeded the sum of its enigmatic parts, as Sarah Louise Kellogg would have understood. Homer, after all, was not some talented trickster, cleverly posing visual riddles for his contemporary audience. By 1866, the searing events and wrenching emotions of the Civil War had already molded him into an insightful humanist whose work would endure.

Let me conclude, therefore, with several reflections about what *Near Andersonville* might say to our own generation, living in the twenty-first century. T. S. Eliot once remarked that "the

appreciation of art is an affair of limited and transient human beings existing in space and time. Both artist and audience are limited." He noted that "no generation is interested in Art in quite the same way as any other; each generation . . . brings to the contemplation of art its own categories of appreciation, makes its own demands upon art, and has its own uses for art."[58] The poet's observation rings especially true when applied to an artist as gifted and evocative as Winslow Homer. At age 30, he was already creating strikingly original images that remain subtle Rorschach tests for later generations.

In this vein, I suggested earlier that Homer's picture had much to say for the 1860s, but little that could readily be seen or heard a century later in the 1960s. Since perceptions are indeed limited by time, *Near Andersonville* may well speak to us in new and different ways. But Eliot went on to observe that what pertains to diverse generations also applies to different individuals; we each make our own unique demands and find our own uses for art. Inevitably, when we scrutinize a Homer picture at close range, we are each struck by distinct elements and come away with diverse observations. For me, *Near Andersonville* conveys a pivotal moment, suspended in time, burdened with unbearable tension and uncertainty. Despite the picture's static and geometric composition, it conveys a life-changing "tipping point" fraught with possibility and danger, hope and disappointment. But that is my own response; others undoubtedly view Homer's Rorschach test differently.

To establish common ground, it occasionally helps to make a comparison with a picture by another artist from a very different time and place. I was reminded of this in 2009 when a much older canvas (by an even younger painter) visited New York from the Netherlands to help honor Manhattan's Dutch

beginnings four hundred years earlier. Johannes Vermeer (1632–1675) was in his mid-twenties when he created *The Milkmaid* (c. 1657–1658), a small image of a robust young working woman, in a spare room, pouring milk from a pitcher to a bowl.

If you have admired Vermeer's luminous paintings, you know that he often linked a woman in the foreground with a far-flung, mostly male world of global war and commerce beyond a window in the upper left.[59] When *The Milkmaid* went on display in the Metropolitan Museum, one art critic commented on this Dutch masterpiece in terms that might also apply to Homer's *Near Andersonville*. Karen Rosenberg called the picture "one of Vermeer's strangest and best works," an "arresting treatment of a prosaic subject," and she concluded that the artist, "in an unprecedented fashion, . . . endows this domestic worker with traits typically reserved for higher-class women: virtue, diligence and a rich interior life."[60]

Granting all the differences in time and place, subject and technique, Homer's painting, like Vermeer's, bestows self-respect on a much caricatured figure from society's margin. Both artists, two centuries apart, invest a humble woman's external situation with dignity and give her their complete attention. Moreover, each painter draws us toward an awareness of her interior thoughts—Homer through the comprehending gaze and Vermeer through delicate highlights on a broad forehead.

Months after Homer finished *Near Andersonville* in 1866, he went abroad for the first time. In France, he encountered recent works by members of the Barbizon School, artists who were rediscovering the dignity of European peasants. Commentators have observed that he took the sensibility of Millet, Corot, and others and transposed their idealized vision onto Southern blacks, as America's closest answer to a rural peasantry. But

the seeds for all of Homer's impressive black images that came in later decades were planted even before he departed for Europe, and they came from a homegrown source.

Unlike his brother Arthur, Winslow had not donned a uniform during the Civil War, and he never lost a limb or mourned an immediate family member, unlike many of the people he depicted. But *Near Andersonville,* as much as the more famous Homer works from 1860s, shows just how actively and deeply he reflected on the agonizing complexities of the conflict. Given the picture's setting and its title, he clearly wants his viewers to witness, from a surprising angle, a crucial moment in a long national drama. The outcome of events in the late summer of 1864, whatever it is to be, will reshape the lives of millions across numerous generations to come. The longer I ponder this picture, the more it strikes me, in its own quiet way, as a revolutionary work of art—in at least three ways.

First of all, Homer literally "foregrounds" a black perspective, placing viewers where they can, and must, consider an enslaved individual's point of view. The artist does more than go behind enemy lines; he inverts traditional hierarchies. In most illustrations of the war, the conflict of Johnny Reb and Billy Yank dominates the foreground. This is true even in non-battle scenes such as *Prisoners from the Front,* Homer's accessible, career-launching tableau from 1866 (Plate 5). But in *Near Andersonville,* which went on view the very same week, the viewpoint has changed dramatically. The contending armies do not disappear; instead, the white soldiers are relegated to the edge of the painting, behind a fence. The black figure dominates the scene with her difficult situation and complex thoughts.

This unusual perspective links the issue of slavery and the drama of emancipation with the strife and suffering of fratricidal

warfare. Her own fate is intertwined with the shifting fortunes of the Union soldiers who pass by on the dusty road, like so many shuffling shades in Dante's *Inferno*. If they are to be imprisoned, she must remain unfree as well. *Near Andersonville* reveals the entire war as a three-sided, not a two-sided struggle, something most Americans are only gradually managing to grasp, and it provides an unfamiliar vantage point on the war's long aftermath, the century of sanctioned inequality that was beginning to unfold in 1866.

The picture's recovery fifty years ago coincided with the push to recover African-American history. On one hand, the 1960s offered little time or space for scholarly reflection on such an unusual picture as *Near Andersonville*. But on the other hand, the intellectual dams that had been in place ever since the end of Reconstruction were beginning to give way. Since then, the outpouring of first-class research on the black experience has grown from a brook to a stream to a mighty river. All of us have benefited from this recent flood of scholarship over the last five decades. But studying this picture reminds us that Homer, more than a century earlier, had already seen the importance of putting a determined black individual front and center. In this regard, most of us are only just catching up to him; his model will continue to serve all of us well.[61]

Second, I am struck that Homer was equally far ahead of the curve in placing such a strong female figure in the foreground, not as an object of pity or desire, but as a thinking being. He is reminding viewers that a woman, whatever her social standing, can be at the center of a deep and important narrative. Needless to say, over the last fifty years, the river of African-American scholarship I just described has intermingled with a second strong current, for the dams holding back serious historical

study of women also began to give way in the 1960s.[62] For decades, increasing numbers of scholars have placed women in the foreground of their research. Not surprisingly, when historian Deborah Gray White published her book on female slaves in 1985, a close-up of Homer's picture, still called *At the Cabin Door*, graced its cover.[63]

Now a new generation of writers is arguing forcefully that the push to improve women's welfare around the world will create a new global "abolition movement" of the twenty-first century.[64] Such authors may not select *Near Andersonville* to grace their covers, but they will have no trouble finding similar images that portray a strong but illiterate woman of color, standing in a doorway in present-day Afghanistan or Sudan, wearing a different head scarf, and eyeing distant soldiers.[65] Homer's painting asked viewers, almost 150 years ago, to push warfare and armed violence to the background; not to ignore and dismiss it, but to look at the world through the eyes of a woman who is poor, oppressed, and dependent on the one hand, but smart, hopeful, and imaginative on the other. She is brimming with potential, yet for most of the world's male elites she was, and remains, even more invisible than Ralph Ellison's "Invisible Man."

Finally, there is a much broader humanism embedded in Winslow Homer's picture that goes beyond race or gender. Even now, Euro-Americans retain ambivalence about what constitutes full humanity. This parochial ambiguity is older than the Puritans, and as recent as the morning paper.[66] But Homer was that rare American humanist who got it right, with very little help. Long before our own time, Homer overcame, to a remarkable degree, the age-old contradictions of ethnocentric European humanism.[67] He repeatedly laid out his sense of "universal humanity" on canvas, and *Near Andersonville* remains one the earliest and

most meaningful expressions of that universal humanism. Homer's compact and unassuming painting, long unknown and hidden from public view, centers around a compelling individual who now deserves far wider recognition.

Luckily, the strong black woman from rural Georgia whom Homer brought to life on canvas has not been entirely forgotten. Though unheard of for generations, she is now living comfortably in northern New Jersey, and we are beginning to get a better sense of who she is and what she represents. During the past half a century, she has traveled little from her museum home in Newark, but over the years she has appeared on the cover of several books and magazines. She continues to have a small circle of admirers and a wide array of acquaintances. Interested people of all ages look in on her regularly in the spacious building on Washington Street. And every week, busloads of local school children gather around to ask respectful questions about her experiences, her feelings, and her point of view. I urge you to pay her a visit.

ABBREVIATIONS

Carbone/Hills — Teresa A. Carbone and Patricia Hills, *Eastman Johnson: Painting America* (New York: Rizzoli, 1999).

Cikovsky/Kelly — Nicolai Cikovsky, Jr. and Franklin Kelly, *Winslow Homer* (New Haven: Yale University Press, 1995).

Corbin Paper — Horace K. Corbin III, "The Capture of *The Captured Liberators,* by Winslow Homer," six-page paper submitted May 18, 1962, for Fine Arts 102, a course taught at Trinity College in Hartford by Professor Charles Ferguson. NM.

Evans, *Horsemen* — David Evans, *Sherman's Horsemen: Union Cavalry Operations in the Atlanta Campaign* (Bloomington: Indiana University Press, 1996).

Forten, *Journal* — Charlotte L. Forten, *The Journal of Charlotte L. Forten,* Ray Allen Billington, ed. (New York: Dryden Press, 1953; Collier Books edition, Toronto: Collier-Macmillan, 1961).

Goodrich/Gerdts — Lloyd Goodrich and Abigail Booth Gerdts, *Record of Works by Winslow Homer,* vol. I, *1846 through 1866* (New York: Spanierman Gallery, 2005).

Hendricks, *Life* — Gordon Hendricks, *The Life and Work of Winslow Homer* (New York: Abrams, 1979).

HW — *Harper's Weekly.*

NM — Newark Museum. [This refers to several museum files related to the acquisition of the Homer painting (#66–354) and contacts with the donors, the Corbin family of New Jersey.]

NYT — *New York Times.*

OR1:38 — *The War of the Rebellion: A Compilation of the Official Records of the Union and Confederate Armies,* Ser. 1, Vol. 38 (Washington, DC: Government Printing Office, 1891).

Simpson — Marc Simpson, *Winslow Homer Paintings of the Civil War* (San Francisco: Bedford Arts, 1988).

Sumner/SHC — Typescript of letter from Arthur Sumner in St. Helena Island, SC, to Nina Hartshorn in Cambridge, MA, #3615 Penn School Papers, Vol. 4, folder 342, Southern Historical Collection, University of North Carolina-Chapel Hill.

Towne, *Letters* — Laura M. Towne, *Letters and Diary of Laura M. Towne, Written from the Sea Islands of South Carolina, 1862–1884,* Rupert Sargent Holland, ed. (Cambridge, MA: Riverside Press, 1912).

Wood/Dalton — Peter H. Wood and Karen C. C. Dalton, *Winslow Homer's Images of Blacks: The Civil War and Reconstruction Years* (Austin: University of Texas Press, 1988).

Wood, *Gulf Stream* — Peter H. Wood, *Weathering the Storm: Inside Winslow Homer's* Gulf Stream (Athens: University of Georgia Press, 2004).

NOTES

I. THE PICTURE IN THE ATTIC

1. Mr. Corbin was president of the Fidelity Union Trust Company of Newark from 1940 to 1954 and then chaired the board of that bank. *NYT*, February 6, 1960, p. 19.

2. In 1966, Robert Corbin told Katherine Coffey, Director of the Newark Museum, that he had "a great many paintings in his house," plus "glassware and colonial ware which he believed belonged to the Stockton family . . . Quakers in South Jersey." Unsigned memo, dated November 7, 1966, summarizing Coffey's "recent conversation with Mr. Corbin," NM.

3. Memo from Katherine Coffey, dated November 7, 1966, regarding conversation with Robert Corbin; Corbin Paper, NM. The undergraduate author used pseudonyms with initial letters that serve to identify all the real protagonists.

4. Corbin Paper, NM.

5. Corbin Paper, NM.

6. "Incidentally, Mr. Corbin said that at one time his sister wanted to sell the Homer painting to a dealer—he did not mention who the dealer was—for $300 but he decided that he would not let it go." Memo of November 7, 1966, by Katherine Coffey, relating a talk with Robert S. Corbin, NM.

7. See Charles F. Eberstadt, *Lincoln's Emancipation Proclamation* (New York: Duschnes Crawford, 1950).

8. Corbin Paper, NM.

9. Receipt written by Lindley Eberstadt at Brookway and countersigned by Horace Kellogg Corbin, Jr., and Robert S. Corbin (n.d.), NM. According to Terry Corbin, "a local New Jersey art dealer" spoke with Eberstadt that spring "and accused him of stealing from him a lost Homer painting which was recently discovered

near" the Corbin residence. Otherwise, the dealer "might have made a killing!" Corbin Paper, NM.

10. "I recall that a photographer called and photographed the exterior of the house, and also a family group on the piazza, which I have and in which I appear. At the same time he made several photographs of the interior, of which this is one." Affidavit signed by C. K. Corbin, February 7, 1962, NM. The elegant home on Newark Avenue has been replaced by a parking lot and a Blockbuster Video store.

11. Lindley Eberstadt to Robert S. Corbin, February 8, 1962, with enclosure giving draft list of the picture's successive owners, based on their conversation the previous evening. NM.

12. A revised statement of provenance, attested on February 15, 1962, by "Horace's five children and heirs, Horace Kellogg Corbin, Jr., William Ogden Corbin, Robert Stockton Corbin, Clementine Corbin Day, and Hannah Corbin Carter, who by signing this document authorize Robert S. Corbin to act for them in this matter." NM.

13. Eberstadt, a member of the Appraisers Association of America, repeated this value in a later appraisal he prepared for Robert S. Corbin, June 3, 1966. The picture remained on its original stretcher, and the label of the original New York art supplier was still partially visible on the back of the canvas. In April, Eberstadt paid $100 to Shar-Sisto, Inc., a respected firm on 72nd Street that specialized in painting restoration, to x-ray the picture and to clean it lightly. In addition, the original frame "had a gold liner which they thought rather harsh in effect," so Eberstadt had his restorer replace it with a "linen liner." Correspondence in NM.

14. Memo of K. Coffey "Re the Homer possible gift," September 28, 1966, NM.

15. "Unfortunately an amateur had attempted to restore *the Captured Liberators* many years ago. Instead of beginning with weak solutions at the unnoticed corners, he went right for the subject matter; and because of the thin surface and dark colors, he had his

difficulties and has left a few damaging marks. . . . It is a shame that it has been varnished, for the varnish gives it a deterring glare and tends to hide the true luster. With distance, however, these imperfections seem to vanish." Corbin Paper, NM.

16. Corbin Paper, NM. See Albert Ten Eyck Gardner, *Winslow Homer, American Artist: His World and His Work* (New York: Clarkson N. Potter, 1961).

17. To gain access to Goodrich, Eberstadt joined forces with Rudolph G. Wunderlich at the prestigious Kennedy Galleries on East 56th Street. Eberstadt and Wunderlich sensed the unknown image would catch Goodrich's attention. They even offered to move it around town for him, if he would agree to prepare a report for the Kennedy Galleries at his earliest convenience.

18. "Both signatures are characteristic of Winslow Homer in their handwriting. Under ultra-violet light, both signatures visualize as old." Goodrich was especially intrigued that the background drama, with its Union prisoners, "is thus the reverse of *Prisoners from the Front*, which shows a Union officer receiving Confederate prisoners." So in June he had the painting "taken to the Metropolitan Museum of Art, where I compared it with the Museum's *Prisoners from the Front*, dated 1866. The resemblances in color, light, technique, and even in details such as the character of the faces, are very close." He also examined X-rays of both paintings and found that they "were very similar. This comparison," he concluded, "was convincing that the two paintings are by the same hand." Goodrich's typed certification, "Prepared for the Kennedy Galleries, 11/15/62." NM.

19. "He assures me he is convinced and the certification will be forthcoming, but wants to make a search of old exhibition lists to see whether he can identify the picture by title." Lindley Eberstadt to Robert S. Corbin, June 19, 1962, NM.

20. Lindley Eberstadt to Robert S. Corbin, July 25, 1962, NM.

21. The picture may have been sent to Chicago for a viewing. One interested buyer, name unknown, died before Eberstadt could discuss a sale.

22. Catalogue for *The Portrayal of the Negro in American Painting* (Brunswick, ME: Bowdoin College Museum of Art, 1964), illustration 43. The exhibition prompted Sidney Kaplan, an English professor at the University of Massachusetts with a strong interest in art and race relations, to include the picture in his pioneering article, "The Negro in the Art of Homer and Eakins," *The Massachusetts Review* 7 (Winter 1966): 105–120. (The painting, shown on p. 107, was incorrectly dated 1875.)

23. Corbin Paper, NM.

24. Memo by Katherine Coffey, dated August 23, 1966, regarding conversation with Robert S. Corbin; letter from Katherine Coffey to Robert S. Corbin, August 24, 1966, NM. When NM Associate Director Mildred Baker spoke with Lloyd Goodrich for assurance regarding the picture's authenticity, he "stated that it is absolutely genuine." Memo from Baker to Director Katherine Coffey, September 8, 1966, NM.

25. Bill Bartle, "Press Release," December 4, 1966, NM.

26. Kevin Mumford, *Newark: A History of Race, Rights, and Riots in America* (New York: New York University Press, 2007), 98.

27. Alain Locke, ed., *The Negro in Art: A Pictorial Record of the Negro Artist and of the Negro Theme in Art* (Washington, DC: Association in Negro Folk Education, 1940), 139. Cf. Ellwood Parry, *The Image of the Indian and the Black Man in American Art, 1590–1900* (New York: George Braziller, 1974).

28. Wood, *Gulf Stream*, 13–16.

29. In 1961, Gardner's "new view of Homer" devoted a chapter to "The Art World of 1840–70 in Boston and New York." A decade later, Tatham's thorough dissertation still had an understandably artistic emphasis. Later, Hendricks concentrated on young Homer's daily life. Gardner, *Winslow Homer*, 63–87; David Tatham, "Winslow Homer in Boston: 1855–1859" (Ph.D. dissertation, Syracuse University, 1970); Hendricks, *Life*, 9–38.

30. See, for example, Louis Ruchames, *The Abolitionists: A Collection of Their Writings* (New York: G. P. Putnam's Sons, 1963); John L. Thomas, *The Liberator: William Lloyd Garrison, A Biography* (Bos-

ton: Little, Brown, 1963); Martin Duberman, ed., *The Antislavery Vanguard: New Essays on the Abolitionists* (Princeton, NJ: Princeton University Press, 1965); and Benjamin Quarles, *Black Abolitionists* (New York: Oxford University Press, 1969).

31. "The Homer family group was an exceptionally close-knit unit, and Winslow and his brothers, Charles and Arthur," Gardner writes, "could play in the nearby fields and woods and fish in the streams and ponds of the neighborhood." Gardner, *Winslow Homer*, 42.

32. Lloyd Goodrich, *Winslow Homer* (New York: Macmillan, 1944), 5.

33. The home stood next to Fay House, where Byerly Hall now sits, in the Radcliffe Yard. Irish-born Maria Flaherty, age 18, is listed with the Homers in the 1850 census.

34. Thomas Wentworth Higginson, *Part of a Man's Life* (Boston: Houghton, Mifflin and Company, 1905; reissued 1971), 118. "Traveling by public conveyance was difficult for blacks. In Boston there were signs: 'Colored people not allowed to ride on this omnibus.'" August Meier and Elliott M. Rudwick, *From Plantation to Ghetto* (New York: Hill and Wang, 1966), 96.

35. Letter to the author from historian Sydney Nathans, who is preparing a biography of Mary Walker, a "white African" from Orange County, NC, who had escaped from servitude in 1848.

36. Cambridge writers contributed to *The Liberty Bell,* a Boston antislavery publication that circulated widely. For example, Edmund Quincy (brother of Boston's mayor and son of Harvard president Josiah Quincy) wrote a short story for this annual giftbook. In it, the New Englander narrator visited South Carolina before the Revolution (as the author's grandfather had done in 1773) and heard an extensive discussion of the Stono Slave Revolt of 1739. Edmund Quincy, "Mount Verney: Or, an Incident of Insurrection," *Liberty Bell* (1847): 165–228, reprinted in Mark M. Smith, ed., *Stono: Documenting and Interpreting a Southern Slave Revolt* (Columbia: University of South Carolina Press, 2005), 35–56.

37. *Narratives of the Sufferings of Lewis and Milton Clarke . . . Dictated by Themselves* (Boston: Bela Marsh, 1846). Lovejoy's brother, the

abolitionist martyr Elijah Lovejoy, had been killed in Alton, Illinois, in 1837 by a pro-slavery mob.

38. After white male students protested the change, Harvard's Overseers elected to back the status quo, despite the efforts of Oliver Wendell Holmes Sr., the respected poet and Parkman Professor of Anatomy and Physiology, who was well known in Cambridge.

39. Gary Collison, *Shadrach Minkins: From Fugitive Slave to Citizen* (Cambridge, MA: Harvard University Press, 1997), 130–133. An assistant court clerk and crier enmeshed at the center of the case was named Henry Homer. Could he have been a distant relation of Winslow Homer, whose uncle Henry Homer had died the previous year?

40. Quarles, *Black Abolitionists*, 207.

41. Quoted in Mary Thatcher Higginson, *Thomas Wentworth Higginson: The Story of His Life* (1914; reissued 1971), 111. Stowe's book saturated Massachusetts. Later in the decade, Higginson wrote to his mother (p. 154): "One funny thing we have heard—a small child, endeavoring to describe a black man in the street, at last succeeded in stammering out, 'It's a Tom Cabin!' and was quite satisfied that he had said the right thing."

42. Albert J. Von Frank, *The Trials of Anthony Burns: Freedom and Slavery in Emerson's Boston* (Cambridge, MA: Harvard University Press, 1998), xviii.

43. Quarles, *Black Abolitionists*, 208.

44. "To-day Massachusetts has again been disgraced," Forten wrote on June 2, 1854; "again has she shewed her submission to the Slave Power; and . . . this on the very soil where the Revolution of 1776 began . . . opposing British tyranny, which was nothing compared with the American oppression of to-day." Forten, *Journal*, 46–47.

45. For further discussion of these prewar images, see Wood/Dalton, 16–31.

46. Harlan Gradin, "Losing Control: The Caning of Charles Sumner and the Breakdown of Antebellum Political Culture" (Ph.D. dissertation, University of North Carolina-Chapel Hill, 1991); David

F. Tatham, "Winslow Homer's *Arguments of the Chivalry*," *American Art Journal* 5, no. 1 (May 1973): 86–89.

47. For a striking assessment of this event, see Elizabeth Rauh Bethel, *The Roots of African-American Identity: Memory and History in Antebellum Free Communities* (New York: St. Martin's Press, 1997), 1–24.

48. *HW*, August 1, 1857, and November 10, 1860.

49. See *HW*, December 22, 1860; January 5 and February 2, 1861.

50. [George W. Sheldon], "American Painters: Winslow Homer and F. A. Bridgman," *The Art Journal* [New York] 4 (August 1878): 227.

51. See *HW*: "Filling Cartridges at the United States Arsenal, at Watertown, Massachusetts" (July 20, 1861); and "Crew of U.S. Steam-Sloop 'Colorado' Shipped at Boston, June 1861" (July 13, 1861).

52. This letter of October 8, 1861, is reproduced in Simpson, 18.

53. Letter in a private collection, from Homer to his father and dated only "Saturday," reproduced in Goodrich, *Life,* 47, where the author gives the less likely date of March 1862.

54. For an interesting comparison regarding the black images of Nast and another major artist, see Patricia Hills, "Cultural Racism: Resistance and Accommodation in the Civil War Art of Eastman Johnson and Thomas Nast," in Patricia Johnston, ed., *Seeing High & Low: Representing Social Conflict in American Visual Culture* (Berkeley: University of California Press, 2006), 103–123.

55. Corbin Paper; Bill Bartle, "Press Release," December 4, 1966, NM.

56. Lindley Eberstadt to Robert S. Corbin, February 8, 1962, with enclosure giving draft list of the picture's successive owners, based on their conversation the previous evening. NM.

57. Revised statement of provenance, attested by Corbin siblings, February 15, 1962, NM.

58. Notes of "BB," made "during Mr. Corbin's visit to Museum 11–16–66"; Katherine Coffey, "Memo—Re: *Title of Homer*," March 21, 1968, NM.

59. Gary A. Reynolds to Lucretia H. Giese, November 9, 1983. (Reynolds gave the same response to another Homer scholar, Phoebe Lloyd, May 20, 1885.) NM.

60. A memo from curator Gary Reynolds to the NM Registrar, January 25, 1988, that "reflects new and more complete information on our Homer," still lists the picture's first owner, after the artist himself, as "Mrs. Elijah Kellogg (nee Martha Banks Crane), Elizabeth, N.J., by 1884." NM.

61. Julia A. Kellogg, a "descendant of first settlers of Elizabeth, N.J.," was educated there in the school of Miss C. D. Spalding. She began her own "teaching career early, but owing to weak eyes for years her teaching was chiefly confined to private classes." An advocate for women's suffrage and a single tax, she became a writer and a charter member of the New England Women's Club in Boston. *Women's Who's Who of America, 1914–1915,* John William Leonard, ed. (New York: American Commonwealth Company, 1914), 450.

62. *NYT,* Monday, June 25, 1866. (I am grateful to Robert MacAvoy for sharing this citation.) SLK was buried beside other family members under a massive copper beech tree that is still standing.

63. Albert Clark, comp., *Family Records of George Clark and Daniel Kellogg: With Their Descendants* (Washington, DC: Albert Clark Patterson, 1877), 24.

64. Willie Lee Rose, *Rehearsal for Reconstruction: The Port Royal Experiment* (Indianapolis and New York: Bobbs-Merrill, 1964), 11–12.

65. Theodore Rosengarten, *Tombee: Portrait of a Cotton Planter* (New York: Morrow, 1986), 202.

66. Augustus Field Beard, *A Crusade of Brotherhood: A History of the American Missionary Association* (Boston: Pilgrim Press, 1909), 169. For the wartime victory of Gideon and his small band of carefully chosen followers, see the Old Testament's Book of Judges, chapters 6–8.

67. This anonymous tribute continued: "Their courage, their self-sacrificing devotion, sincerity of purpose, and purity of motive . . . were their pass keys to the hearts of those for whom they came to labor. . . . No mercenary or sordid motives attaches to their fair names. . . . As long as the human heart beats in grateful response to benefits received, these women shall not want a monu-

ment of living ebony and bronze." Quoted in Beard, *Crusade,* 233–234.

68. "It was a voyage never to be forgotten," Pierce wrote, echoing the *Mayflower*'s William Bradford. "The enterprise was new and strange, and it was not easy to predict its future. Success or defeat might be in store for us; and we could only trust in God, that our strength would be equal to our responsibilities." In his shipboard sermon to the teacher "colonists," the Harvard Law School graduate "enjoined patience and humanity" and "impressed on them the greatness of their work." Edward L. Pierce, "Freedmen at Port Royal," *Atlantic Monthly* 12 (September 1863): 298.

69. Henry L. Swint, *The Northern Teacher in the South, 1862–1870* (Nashville, TN: Vanderbilt University Press, 1941), 41, 175–200.

70. When historian Ray Allen Billington edited the journal of Charlotte Forten, an important figure in the Port Royal Experiment, he mistakenly assumed all her references to "Miss Kellogg" involved Martha. Forten, *Journal,* 224, 277 (note 88). Later editions have fallen into the same trap. See *The Journals of Charlotte Forten Grimké,* Brenda Stevenson, ed. (New York: Oxford University Press, 1988), 510, 605 (note 60).

71. In *The Northern Teacher,* Swint listed the names of hundreds of instructors serving in the South during and after the Civil War, whose home towns he had located. He discovered that Martha Louise Kellogg (b. 1823) wrote a published letter from Hilton Head, South Carolina, early in 1863. Therefore, he plausibly but mistakenly assumed that all Kellogg references from that area linked to her, the only Kellogg on his long but incomplete list.

72. Forten, *Journal,* 224.

73. Sumner describes a carriage wreck on a sandy road that led to "a lame side and neck for Miss Kellogg for two days" and put him on crutches for three weeks: "Couldn't even go down to see Sarah off" when she departed. "I already mourn for her as if she were no more. And our household was so happy. We four were so comfortable and cosy together,—round our brave old fire of oaken logs, and our snug little parlor with good books, a good

table, and good friends." February 1865, Sumner/SHC. Italics added.

74. Towne reported that as Miss Kellogg's coughing increased, "she wrote to her doctor in New York about it. The consequence was an order from him and beseeching letters from her friends. . . . Harriet Ware says she will go by the same steamer so as to take care of her." Typescript of letter from St. Helenaville, South Carolina, dated Saturday, January 21, 1865, from Laura Towne to her sister, #3615 Penn School Papers, Box 33, Vol. 3, Part II, folder 338, pp. 366–367. Southern Historical Collection, University of North Carolina-Chapel Hill.

75. Sumner, like Towne, was part of the initial Gideonite band, and he had set up a school on the Oliver Fripp estate on St. Helena Island. Another teacher in the area reported, "Mr. Chas. Williams was superintendent in the place, but it is now a school-farm, leased by Mr. Sumner." William F. Allen, like Sumner, was a male from Massachusetts, so he may have given too little credit to Towne, Kellogg, and Forten when he wrote: "Mr. Sumner has been teaching there for two years, and I suppose has the best school on the island. Miss Kellogg assists him, and Miss Fortin (a mulatto) lives with them" and also teaches. Journal entry for March 20, 1864, Box 1, page 152, Allen Family Papers, Archives of The State Historical Society of Wisconsin in Madison.

76. "We are having very pleasant times in our house now. We have two ladies to live here. Isn't it funny? . . . I asked [Miss Kellogg] to come over and help me in my work in school. She said she would come if I would get another lady for company. So Miss Forten, that young colored lady about whom I wrote you, agreed to join us. We live as cosily as four cats. . . . They are very lovely and loveable young women. Miss Kellogg, though, I guess, is as much as thirty five. My school is, of course, vastly benefitted by her assistance." December 19, 1863, Sumner/SHC.

77. On December 5, 1864, Laura Towne wrote, "I have been having a nice visit from Louise Kellogg. She has settled down in Mr. Sum-

ner's house and seems very well content." Towne, *Letters*, 142–143 (cf. 110, 130, 136).

78. December 13, 1864, Sumner/SHC.

79. Later, "we took boat again" for an overnight excursion to a vacant plantation. The house had been stripped of furnishings, and after a sleepless night on the floor Laura felt exhausted when they returned to the ship the next day. "I could only lie down, and could not go to the dinner provided." Towne, *Letters*, 109–110 (Entry for June 3, 1863). Cf. Elizabeth Ware Pearson, ed., *Letters from Port Royal* (Boston: W. B. Clarke Co., 1906; reprinted with a new introduction by James M. McPherson, New York, Arno Press, 1969), 176, 213.

80. A book from 1911 reprinted verbatim the encomium for Miss Kellogg (note 63 above) from a genealogist in 1877. See Lucy Ann (Morris) Carhart, comp., *Genealogy of the Morris Family; Descendants of Thomas Morris of Connecticut* (New York: A. S. Barnes Co., 1911), 62.

81. Towne had remained at St. Helena, founding the Penn School with her partner Ellen Murray. "We are going . . . to have lots of company," Towne noted in February 1868; "Miss Julia Kellogg writes that she will visit us . . . for two weeks." Towne, *Letters*, 189.

82. For me, this gradual disappearance from memory brings to mind the prize-winning novel of Marilynne Robinson, *Gilead* (New York: Farrar, Straus and Giroux, 2004), set in the 1950s. The narrator, John Ames, is a white minister in his seventies facing death in small-town Iowa as the far-off civil rights movement unfolds on his flickering television. Looking back, he struggles to reconnect to the life of a radical New England grandfather, who joined John Brown in Kansas and lost an eye serving in the Union Army. Looking forward, Ames tries equally hard to understand a young namesake who has married an African-American woman and become a father. Robinson knows that in the 1850s and 1860s a generation had challenged America's monumental racial injustice, and she shows how, a century later, mainstream Americans had forgotten or marginalized that commitment.

2. BEHIND ENEMY LINES

1. Notes prepared by Lloyd Goodrich for Rudolph Wunderlich of the Kennedy Galleries, regarding Winslow Homer oil painting, November 15, 1962; Edith Goodrich to Mildred Baker (NM Associate Director), February 3, 1967, NM. (Based on internal evidence, the second letter's true date is March 3.)

2. "Re: *Title of Homer*," Memo of March 21, 1967, from Katherine Coffey to Registrar. NM.

3. *NYT*, January 20, 1978. Mr. Rockefeller died in an auto accident six months later. The donation was completed in 1979 by his widow, Blanchette Hooker Rockefeller, then the president of New York's Museum of Modern Art.

4. In a letter to Sally Mills dated September 25, 1987 (NM), Newark curator Gary A. Reynolds explained that the picture's provenance, from the donors, "is based entirely on information from the family, who never knew exactly how their great grandmother had acquired the painting. . . . The painting was cleaned (some have said over cleaned) by Shar-Sisto, Inc., New York, in 1962, several years before coming into our collection. In 1966 the Museum had Bernard Rabin examine and treat the painting. At that time it was relined (wax) and fit onto a new stretcher. In the relining process a New York canvas-maker's stamp on the back of the painting was covered. . . . Unfortunately, it was not written down before the lining."

5. Simpson, relating their Eureka Moment, tells how the pair rushed to borrow the list and then began panning for gold even as they returned to their car. "I distinctly remember reading aloud the few passages," Simpson states, "as Sally drove us back to the museum." He recalls spotting the nugget they were after, "—and both of us whooping when I came to that one—mid-intersection, on-coming traffic, her hands wholly off the wheel. Martyrs to art history." Marc Simpson to Peter H. Wood, March 14, 2008, in possession of PHW.

6. "Sale of Pictures," *The Evening Post*, Thursday, April 19, 1866, p. 3, column 7. An earlier notice ("American Artists' Sale," *NYT*, Tuesday,

April 17, 1866, p. 6) mistakenly lists the artist as "Winslow Hosmer" but offers further details. "This is the first sale this season where the pictures have been exclusively of our native school, and entirely owned by the artists themselves. . . . The collection is now on exhibition day and evening, until time of sale."

7. Marc Simpson to Gary Reynolds, December 16, 1987, NM.

8. Later, even Walt Whitman would speak out. The poet's letter in the *NYT* (December 27, 1864) expressed the widely felt resentment among whites in the North over their government's determined but costly "stand on the exchange of all black soldiers."

9. Charles W. Sanders, Jr., *While in the Hands of the Enemy: Military Prisons in the Civil War* (Baton Rouge: Louisiana State University Press, 2005); Robert Scott Davis, *Ghosts and Shadows of Andersonville: Essays on the Secret Social Histories of America's Deadliest Prison* (Macon, GA: Mercer University Press, 2006).

10. William Marvel, *Andersonville: The Last Depot* (Chapel Hill: University of North Carolina Press, 1994), 100–103. For a useful online resource prepared in 2000 by Ronald J. Caldwell, see "Andersonville: A Selective Bibliography": http://www.gsw.edu/~library/Andersonville.htm.

11. Marvel, *Andersonville*, 238, 305 (note 72). An early tabulation put total deaths for fourteen months at 12,878. *NYT*, May 8, 1865.

12. "When the Rebels acquire a Negro soldier, if he is already wounded they either shoot him instantly [or] if not badly wounded they capture him so that he may work for them when he recovers." Robert K. Sneden, *Eye of the Storm: A Civil War Odyssey* (New York: Free Press, 2000), 213. "Confederates regarded the [Union's] employment of African American soldiers as such a crime against humanity that they felt absolved from any obligation to treat black troops and their white officers as honorable opponents." Gregory J. W. Urwin, " 'We *Cannot* Treat Negroes . . . as Prisoners of War': Racial Atrocities and Reprisals in Civil War Arkansas," in *Black Flag Over Dixie: Racial Atrocities and Reprisals in the Civil War,* Gregory J. W. Urwin, ed. (Carbondale: University of Southern Illinois Press, 2004), 146.

13. "UNION PRISONERS IN ANDERSONVILLE, GA," *NYT*, July 26, 1864.
14. Marvel, *Andersonville*, 239; cf. Alan Huffman, *Sultana: Surviving Civil War, Prison, and the Worst Maritime Disaster in American History* (New York: Smithsonian Books, 2009).
15. Douglas Gibson Gardner, "Andersonville and American Memory: Civil War Prisoners and Narratives of Suffering and Redemption," (Ph.D. dissertation, Miami University, Ohio, 1998); Ann Fabian, *The Unvarnished Truth: Personal Narratives in Nineteenth-Century America* (Berkeley: University of California Press, 2000), chapter 4, "Prisoners of War," 117–157. Cf. Chapter Three, note 1, below.
16. Peggy Sheppard, *Andersonville, Georgia, USA* (Andersonville, GA: Sheppard Publications, 1973), 52. Sheppard reprints Barton's full report. On the relation of local blacks to the camp, see the informative recent article of Robert Scott Davis, "'Near Andersonville': An Historical Note on Civil War Legend and Reality," *Journal of African American History* 92 (Winter 2007): 96–105.
17. Drew Gilpin Faust, *This Republic of Suffering: Death and the American Civil War* (New York: Knopf, 2008), 212–217. See illustration in *HW*, October 7, 1865.
18. *HW*, September 16, 1865, pp. 582, 584–585; October 21, 1865, p. 722. A *Harper's* editorial on November 25 (p. 739) asserted the "horrors of Andersonville were but the natural and inevitable result of the system of slavery which this country so long tolerated."
19. "The Andersonville Prison," *NYT*, November 26, 1865.
20. Sheppard, *Andersonville, Georgia*, 57–65. The Bibb City Ramblers included a song about "The Hanging of Henry Wirz" on their 2009 album, *Andersonville*. Two generations earlier, national awareness of Andersonville had an upsurge after the publication of MacKinlay Kantor's popular novel *Andersonville* (Cleveland and New York: World Publishing Co., 1955). Access to the backstory for this Cold War best seller begins with Tim Kantor, *My Father's Voice: MacKinlay Kantor Long Remembered* (New York: McGraw-Hill, 1988). At the end of the century, the Park Service established a general Prisoner-of-War Museum at the Andersonville site.

21. Letter of October 28, 1861, in a private collection, quoted in Hendricks, *Life*, 45. Homer had taken lodging at Mrs. Foster's, 331 F Street.

22. Everett "saw that he could use emotion to link the fate of house and nation. He would have Mount Vernon symbolize the Union, and by helping to preserve the first he would also help to preserve the second. . . . He delivered the speech a total of 129 times, usually to immense audiences." George B. Forgie, *Patricide in the House Divided: A Psychological Interpretation of Lincoln and His Age* (New York: Norton, 1979), 168–173.

23. Scott E. Casper, *Sarah Johnson's Mount Vernon: The Forgotten History of an American Shrine* (New York: Hill and Wang, 2008), 82–92. (Alfred Waud's image of the estate appears following p. 140.)

24. Willie Lee Rose, *Rehearsal for Reconstruction: The Port Royal Experiment* (Indianapolis and New York: Bobbs-Merrill, 1964), 13–22. Butler put Edward L. Pierce (another Massachusetts attorney) in charge of supervising these newcomers, and Pierce soon wrote an optimistic review of his project for the *Atlantic Monthly* (November 1861). So when the "Big Gun Shoot" at Port Royal liberated thousands of Sea Island slaves that same month, Treasury Secretary Salmon P. Chase recruited Pierce as the ideal person to oversee this "abandoned property" in South Carolina. Within weeks Pierce was recruiting his band of Gideonites that would eventually include Sarah Kellogg.

25. Carbone/Hills, 11–16, 186.

26. For example, Johnson's Civil War painting, *The Lord is My Shepherd* (c. 1863) shows a seated black man drawing strength from an open Bible. Homer's *Sunday Morning in Virginia* (1877) elaborates on the same theme, using a similar interior setting.

27. Patricia Hills, "Painting Race: Eastman Johnson's Pictures of Slaves, Ex-Slaves, and Freedmen," in Carbone/Hills, 120–165. In *Union Soldiers*, the central young black woman stands in shadows, "a metaphor for the unknown travails that await her. She is now unsure of her role or the possibilities open to her, yet the sunny landscape

background suggests a bright future" (138). Hills does not make the association, but ripening apples overhead and this figure's distinctive profile combine to suggest she may be pregnant. See the discussion of pregnancy in Chapter Three below.

28. Once, more than sixty years ago, the Oklahoma Art Center in Oklahoma City brought together pictures by Johnson and Homer for an exhibition. "With the exception of spadework done by Patricia Hills and John Wilmerding, scholarship on the relationship between the two artists remains thin. . . . A thorough diagram of similarities, exchanges, and appropriations between Johnson and Homer . . . would look like a dense web of crisscrossing lines, some running one way, others in both directions." Sarah Burns, "In Whose Shadow? Eastman Johnson and Winslow Homer in the Postwar Decades," in Carbone/Hills, 185.

29. Hills, "Painting Race," in Carbone/Hills, 126.

30. For Lincoln's speech of June 16, 1858, see Mario M. Cuomo and Harold Holzer, eds., *Lincoln on Democracy* (New York: Harper-Collins, 1990), 105–113. Lincoln was not the first national politician to paraphrase the New Testament verse from Matthew 12:25. For earlier quotes by Sam Houston and Daniel Webster, see Forgie, *Patricide,* 201.

31. "Their patterns of work and travel were strikingly congruent as well. As artist-civilians they toured Union army encampments and even witnessed action in the course of the Civil War." Burns, "In Whose Shadow?" in Carbone/Hills, 188.

32. The year Homer died, his friend R. M. Shurtleff reminisced, "His very first picture in oils was painted in [Homer's] studio in the old University Building in Washington Square. It represented a 'Sharpshooter' . . . aiming at a distant 'Reb,' a canvas about 16 × 20. I sat with him many days while he worked on it, and remember discussing with him how much he could ask for it. He decided not less than sixty dollars, as that was what Harper paid him for a full page drawing on the wood." "Shurtleff Recalls Homer," *American Art News* 9, no. 3 (October 29, 1910): 4. See "The Army of the Potomac–A

Sharp-Shooter on Picket Duty. (From a painting by W. Homer, Esq.)," *HW*, November 15, 1862.

33. Steven Conn and Andrew Walker, "The History in the Art: Painting the Civil War," *Art Institute of Chicago Museum Studies*, vol. 27, no. 1, *Terrain of Freedom: American Art and the Civil War* (2001): 79–80.

34. In the late 1980s, while Marc Simpson was preparing his show on "Winslow Homer's Paintings of the Civil War," Karen Dalton and I were hard at work on a parallel exhibition entitled "Winslow Homer's Images of Blacks: The Civil War and Reconstruction Years." The two resulting books (Simpson; Wood/Dalton) still offer the context for exploring *Near Andersonville*. Other useful works include Julian Grossman, *Echo of a Distant Drum: Winslow Homer and the Civil War* (New York: H. N. Abrams, 1974; reprinted in 1991 as *The Civil War: Battlefields and Campgrounds in the Art of Winslow Homer*), and Cikovsky/Kelly. The strength of Homer's wartime sketches is now fully apparent in Goodrich/Gerdts.

35. Besides Figures 5 and 6, see "The War for the Union—A Cavalry Charge" (*HW*, July 5, 1862).

36. Mrs. Homer reported that "plug tobacco & coffee" had been Winslow's staples during these hard weeks. She expected him home for the Fourth of July; until then, "Win is not doing much[,] just paying his expenses." Letter of June 7, 1862, in a private collection, quoted in Hendricks, *Life*, 50.

37. Nicolai Cikovsky, Jr., "The School of War," in Cikovsky/Kelly, 19.

38. Henry Louis Gates, Jr., and Donald Yacovone, eds., *Lincoln on Race and Slavery* (Princeton, NJ: Princeton University Press, 2009).

39. *HW*, "The Songs of the War" (November 23, 1861); "A Bivouac Fire on the Potomac" (December 21, 1861). For a fuller discussion of these and other images mentioned in this section, see Wood/Dalton.

40. Rarely reproduced, *The Shackled Slave* appears in Hendricks, *Life*, 56.

41. *HW*, February 28, 1863.

42. *HW*, January 17, 1863. The prior sketch, labeled "A Shell in the Trenches before Richmond," is in Goodrich/Gerdts, 215.

43. Patricia Hills, "Winslow Homer," in Nancy Rivard Shaw, ed., *American Paintings in the Detroit Institute of Arts,* volume II (New York: Hudson Hills Press, 1997), 119.

44. Simpson, 180–187, identifies numerous tales of bravado. As yet, no documentation settles the question of Homer's presence completely, but his sketch of a particularly denuded landscape (Simpson, 183) was probably made in the area, providing the stump-filled setting for the eventual painting.

45. Alan Axelrod, *The Horrid Pit: The Battle of the Crater, The Civil War's Cruelest Mission* (New York: Carroll and Graf Publishers, 2007); John F. Schmutz, *The Battle of the Crater: A Complete History* (Jefferson, NC: McFarland, 2009); Richard Slotkin, *No Quarter: The Battle of the Crater, 1864* (New York: Random House, 2009); Earl J. Hess, *In the Trenches at Petersburg: Field Fortifications and Confederate Defeat* (Chapel Hill: University of North Carolina Press, 2009).

46. Grant to Halleck, *The War of the Rebellion: A Compilation of the Official Records of the Union and Confederate Armies,* Ser. 1, Vol. 40 (Washington, DC: Government Printing Office, 1891), Part I, 17.

47. Cikovsky/Kelly, 47; Goodrich/Gerdts, 316–318. Simpson mentions "the spectacular Petersburg mine" (182) but does not link it to the picture; he notes the minstrel figure only as a "black laborer, playing a banjo" (181). On casualties, see Slotkin, *No Quarter,* 318.

48. See Richard Slotkin, *No Quarter,* and his earlier document-filled novel, *The Crater* (New York: Atheneum, 1981), which included a portion of Homer's painting on the dust jacket.

49. In Arkansas, several days before The Crater occurred in Virginia, "the dogged determination" of African American soldiers "to fight to the end" had proven crucial in an engagement where "black troops constituted the majority of the Union force involved." Brian K. Robertson, "'Will They Fight? Ask the Enemy': United States Colored Troops at Big Creek, Arkansas, July 26, 1864," *Arkansas Historical Quarterly* 66, no. 3 (Autumn 2007): 332.

50. Quoted in Slotkin, *No Quarter,* 317.

51. Faust, *Republic of Suffering,* 46–47. Faust adds, "In practice, it would prove impossible for Confederates to maintain a policy of killing all black prisoners, at least in part because of the threatened Union reprisals. Some African Americans were treated as prisoners of war, as, for example, the approximately one hundred men incarcerated at Andersonville." One black prisoner who did not survive Andersonville was Thomas Eston Hemings, a grandson of President Thomas Jefferson. Annette Gordon-Reid, *The Hemingses of Monticello: An American Family* (New York: W. W. Norton, 2008), 587.

52. Rounded Union casualty figures at Kennesaw Mountain (June 27), Peachtree Creek (July 20), and the Battle of Atlanta (July 22) came to 3,000, 1,700, and 3,600, respectively.

53. Special Field Order No. 42, July 25, 1864, *OR*1:38, Part V, 255–256. On the eve of departure, Sherman (p. 260) estimated the strength of each force to be "about 3,500 cavalry, under General McCook, and . . . about 5,000 under Stoneman." He guessed that Andersonville contained about "20,000 of our men." Evans, *Horsemen,* 202, puts the initial cavalry corps at "almost 10,000 strong."

54. Report of Major General Sherman, September 15, 1864, *OR*1:38, Part I, 75–76.

55. Major General George M. Stoneman to Major General Sherman, July 26, 1864, *OR*1:38, Part V, 264.

56. Report of Major General Sherman, September 15, 1864, *OR*1:38, Part I, 76.

57. Major General Sherman to Major General George M. Stoneman, July 26, 1864, *OR*1:38, Part V, 265. Cf. Richard W. Iobst, *Civil War Macon: The History of a Confederate City* (Macon, GA: Mercer University Press, 1999), 321–322.

58. Albert Castel, "Stoneman's Raid (26 July–31 July 1864)" in David S. Heider, ed., *Encyclopedia of the American Civil War* (Santa Barbara, CA: ABC-CLIO, 2001), entry 1447.

59. James M. McPherson, *Battle Cry of Freedom* (New York: Oxford University Press, 1988), 755; Marc Wortman, *The Bonfire: The Siege and Burning of Atlanta* (New York: PublicAffairs, 2009), 283.

60. I have used the thorough recent account in Evans, *Horsemen*, chapters 11–20, unless noted. This treatment supersedes such earlier works as A. A. Hoehling, *Last Train from Atlanta* (New York: Thomas Yoseloff, 1958), 166–207; Samuel Carter III, *The Siege of Atlanta, 1864* (New York: St. Martin's Press, 1973), 238–265; and Byron H. Mathews, Jr., *The McCook-Stoneman Raid* (Philadelphia: Dorrance & Co., 1976).

61. On July 25, Brigadier General Kenner Garrard pleaded with Sherman for postponement on the grounds that a thousand of his cavalry horses needed to be reshod. "I would like to give you all the time you request for rest, reshoeing, etc.," Sherman replied, "but am advised by General Grant that I must be prepared for a reinforcement to the Rebel Army from Virginia and want to prevent it." Major General Sherman to Brig. Gen. Kenner Garrard, July 25, 1864, *OR*1:38, Part V, 250–251.

62. Major General Sherman to Major General Halleck, 9:00 P.M., July 28, 1864, *OR*1:38, Part V, 279.

63. Quoted in Mathews, *McCook-Stoneman Raid*, 69.

64. In the violent fighting, Confederate Colonel Henry M. Ashby's men succeeded in "completely surrounding and capturing the one hundred fifty men of the Fourth Indiana, two companies of the second Indiana, and four companies of the Second Kentucky." Mathews, *McCook-Stoneman Raid*, 95. General Wheeler's account is in *OR*1:38, Part III, 954–957.

65. Beers, a Northern woman married to a Southerner, describes ministering to wounded Federal soldiers as well as Confederates. "Some lay as if peacefully sleeping; others, with open eyes, seemed to glare at any who bent above them. Two men lay as they had died, the 'Blue' and the 'Gray,' clasped in a fierce embrace. What had passed between them could never be known; but one was shot in the head, the throat of the other was partly torn away. . . . So we went on, giving water, brandy, or soup; sometimes successful in reviving the patient, sometimes only able to whisper a few words of comfort to the dying." Fannie A. Beers, *Memories: A Record of Personal Experience and Adventure*

During Four Years of War (Philadelphia: J. B. Lippincott, 1888), 152–154.

66. Quoted in Evans, *Horsemen*, 323.

67. Evans, *Horsemen*, 356–357, 362–363, 478–479; Morton R. McInvale, "'That Thing of Infamy', Macon's Camp Oglethorpe During the Civil War," *Georgia Historical Quarterly* 63, no. 2 (Summer 1979): 279–291.

68. Quoted in Evans, *Horsemen*, 355, 358.

69. As one survivor later wrote, "All during July the prisoners came streaming in by hundreds and thousands from every portion of the long line of battle, stretching from the eastern bank of the Mississippi to the shores of the Atlantic." These included "thousands from Grant's lines in front of Petersburg. In all, seven thousand one hundred and twenty-eight were, during the month, turned into that seething mass of corrupting humanity to be polluted and tainted by it, and to assist in turn to make it fouler and deadlier." Deaths during July numbered 1,817 "—more than were killed at the battle of Shiloh—" leaving 31,678 still imprisoned. "Let me assist the reader's comprehension of the magnitude of this number by giving the population of a few important Cities, according to the census of 1870: Cambridge, Mass—39,639 . . . Charleston, SC—48,956 . . . Lawrence, Mass—28,921 . . . Savannah, Ga.—28,235." John McElroy, *Andersonville: A Story of Rebel Military Prisons* (Toledo, OH: D. R. Locke, 1879), 258–259.

70. Evans, *Horsemen*, 359. Though Wirz later claimed he had been absent, records suggest that he was present, and he was identified by many of Stoneman's men. Ibid., 564, note 6.

71. "They report Gen. Stoneman as being himself a prisoner. If they would treat officers as they do privates it would soon bring on an exchange." Sergeant William F. Keys (age 25, 143rd Pennsylvania Infantry), in William Styple et al., *Andersonville: Giving up the Ghost* (Kearny, NJ: Belle Grove Publishing, 1996), 39.

72. Private George A. Hitchcock, age 20, of the 21st Massachusetts Infantry had arrived at Andersonville in mid-June. Styple, *Ghost*, 67.

73. Sergeant William F. Keys, in Styple, *Ghost,* 39. Keys had been captured in Virginia at the Battle of the Wilderness in early May.
74. *NYT,* August 24, 1864. Cf. Melville's poem, "In the Prison Pen," written in 1864, in Herman Melville, *Battle-Pieces and Aspects of the War* (New York: Harper and Brothers, 1866), 118–119.
75. The correspondent ("B.C.T.") said he had been "informed confidentially" at the outset that Stoneman's ultimate "objective point was Andersonville," where "some thirty thousand of our soldiers are 'cooped' in an immense stockade," but that he had not mentioned this fact in his earlier reports in order to protect the mission's secrecy. "The Raids Under Stoneman and McCook," *NYT,* September 1, 1864.
76. W. E. B. Du Bois, *Black Reconstruction in America* (New York: Atheneum, 1975; first published in 1935), 61.

3. THE WOMAN IN THE SUNLIGHT

1. Northern news accounts of Andersonville, plus grim calling cards that circulated dismaying pictures of emaciated prisoners, were supplemented by actual encounters with survivors. Charles Hopkins, for example, arrived in Newark the same week Lincoln was assassinated. Too weak to sit up, he proceeded home to Boonton by stagecoach, draped across the laps of three sobbing and comforting women friends. "Somehow, the word of my coming had reached my home town, ahead of the stage and a great crowd had collected . . . to see a real Andersonville prisoner. Well, they saw him, as fast as they could pass in and out of the room. Our former family Doctor objected, but I insisted that it could do me no harm—I won." William B. Styple and John J. Fitzpatrick, eds., *The Andersonville Memoirs and Diary of Charles Hopkins* (Kearny, NJ: Belle Grove Publishing, 1988), 177–178.
2. Both paintings are the focus of recent books. Jonathan Miles, *The Wreck of the Medusa* (New York: Atlantic Monthly Press, 2007); John Elderfield, *Manet and the Execution of Maximilian* (New York: Museum of Modern Art, 2006). For earlier studies devoted to

single paintings, see the brief list in Wood, *Gulf Stream*, 93, note 1. At least one great painting, Rembrandt's *Night Watch*, now has its own opera, documentary film, and feature movie. *NYT*, October 21, 2009, pp. C1, C6.

3. See "The Yankees Are Coming," Goodrich/Gerdts, 200.

4. See, for example, *A Woman's Work is Never Done* (1882), by Seymour J. Guy (1824–1910), a contemporary of Homer, in Annette Blaugrund, *The Tenth Street Studio Building: Artist-Entrepreneurs from the Hudson River School to the American Impressionists* (Southampton, NY: The Parrish Art Museum, 1997), 40.

5. *HW*, June 11, 1870. Homer made several oil versions of the same picture that experimented with this liminal space. One shows the woman with a horn standing just outside the house, still close to her domestic vines and pots; another shows her inside a large porch, standing in shade rather than sun. See Hendricks, *Life*, 84.

6. Richard Hofstadter, *The American Political Tradition and the Men Who Made It* (New York: Knopf, 1974), 86–117; Drew Gilpin Faust, *James Henry Hammond and the Old South* (Baton Rouge: Louisiana State University Press, 1982).

7. Abraham Lincoln, *Lincoln on Democracy*, Mario M. Cuomo and Harold Holzer, eds. (New York: Harper & Row, 1990). Lincoln spoke to the Wisconsin Agricultural Society in September 1859; he repeated his critique of "mudsillism" in his first State of the Union remarks to Congress in December 1861.

8. "The Seceding South Carolina Delegation," *HW*, December 22, 1860.

9. For the "mud-sill" portion of his original speech to the Senate on March 4, 1858, see James Henry Hammond, *Selections from the Letters and Speeches of the Hon. James H. Hammond, of South Carolina* (New York: John F. Trow and Co., 1866), 318.

10. Robert Frost, *Collected Poems of Robert Frost* (New York: Halcyon House, 1939), 131.

11. See, for example, Edmund L. Drago, "How Sherman's March through Georgia Affected the Slaves," *Georgia Historical Quarterly* 58, no. 3 (Fall 1973): 361–375.

12. *The Liberator*, June 24, 1864.
13. David E. Long, *The Jewel of Liberty: Abraham Lincoln's Re-election and the End of Slavery* (Mechanicsburg, PA: Stackpole Books, 2008), 207.
14. George Templeton Strong, *Diary of the Civil War, 1860–1865*, Allan Nevins, ed. (New York: Macmillan Company, 1962), 467, 474.
15. Long, *Jewel of Liberty*, 121–122, 129. As the president's stance became known, public reaction was swift. "Lincoln's blunder in his letter 'to all whom it may concern' may cost him the election," George Templeton Strong wrote. "By declaring that abandonment of slavery is a fundamental article in any negotiation for peace and settlement, he has given the disaffected and discontented a weapon that doubles their power of mischief." Strong, *Diary*, 474.
16. "It's wonderful," Strong reflected, "what an ill savor the word Abolition has acquired during our long period of subjugation by the slaveholding caste. One would think it a good word, and likely to be popular with a free people, but it isn't. I never call myself an Abolitionist without a feeling that I am saying something rather reckless and audacious." Strong, *Diary*, 474.
17. John Stauffer, *Giants: The Parallel Lives of Frederick Douglass and Abraham Lincoln* (New York: Twelve, 2008), 275–277. No incumbent president had been elected to a second term in more than thirty years.
18. The will of the people, "constitutionally expressed, is the ultimate law for all," the president observed. "If they should deliberately resolve to have immediate peace even at the loss of their country, and their liberty, I know not the power or the right to resist them. It is their own business, and they must do as they please." Roy P. Basler, ed., *The Collected Works of Abraham Lincoln*, 9 vols. (New Brunswick, NJ: Rutgers University Press, 1953–1955), 8:52.
19. *Chicago Times*, August 1, 1864.
20. Quoted in Paul Kendrick and Stephen Kendrick, *Douglass and Lincoln* (New York: Walker & Company, 2008), 200–201 (emphasis in Douglass's original account). "The dimmed light in his eye, and the deep lines in his strong American face," Douglass later

recalled, "told plainly the story of the heavy burden of care that weighed upon his spirit" (194–195).

21. Long, *Jewel of Liberty*, 235.

22. The date is often muddled. On September 2, Secretary of War Stanton heard directly from Major General H. W. Slocum on the scene: "General Sherman has taken Atlanta." But Sherman himself was then south of the city and unsure the capture was complete. Finally, at 6:00 A.M. on September 3, he sent his message from near Lovejoy Station; it reached Washington at 5:30 P.M. on September 4. *OR*1:38, Part V, 763, 777.

23. Long, *Jewel of Liberty*, 283–284.

24. Bernard F. Reilly, Jr., *American Political Prints, 1766–1876* (Boston: G. K. Hall, 1991), 529–531. (All prints discussed appear in Reilly, pp. 527–544.) One anti-Democratic cartoon (529) was entitled "How Columbia receives McClellan's Salutation for the Chicago Platform," and it referred to "those odious 'planks'." Another, called "Platforms Illustrated" (531), showed Lincoln on a solid platform alongside Lady Liberty and a proud eagle, held aloft by Grant, Sumner, and Admiral David Farragut; in contrast, Democrats were shown propping up McClellan on a platform made from a "frail slippery" box of cheese.

25. Mark E. Neely, Jr. and Harold Holzer, *The Union Image: Popular Prints in the Civil War North* (Chapel Hill: University of North Carolina Press, 2000), 134, 140.

26. One 25-cent lithograph, entitled "The Abolition Catastrophe, Or the November Smash-up," predicted a Republican train wreck. It shows Lincoln's "Abolitionism Express" crashing into boulders marked "Emancipation" and "To Whom It May Concern." McClellan's train speeds past on a clear track to the White House, as supporters shout, "Little Mac is the boy to smash up all the Miscegenationists." Reilly, *American Political Prints*, 543–544.

27. Neely and Holzer, *Union Image*, 140. Cf. the Currier and Ives lithograph, "Your Plan and Mine" (146). In one panel, Little Mac, obedient to the Democratic platform, offers an olive branch to Jeff Davis and hands over a black Union soldier to be reenslaved. In

the other scene, in contrast, the Republican Lincoln knocks Davis to his knees, forcing unconditional surrender.

28. Neely and Holzer, *Union Image*, 140–145.

29. Cikovsky/Kelly, 26.

30. Wood, *Gulf Stream*. In fairness, skepticism to this approach lingers. Conservative art critic Roger Kimball declared my book's "egregious importation of racial politics into Winslow Homer's work" to be an utter "travesty." *The New Criterion* 23, no. 4 (December 2004): 82. Elsewhere, Kimball devoted a whole chapter to the ways modern scholarship has ruined Homer's *Gulf Stream*, starting with an article I published in 1981. Roger Kimball, *The Rape of the Masters: How Political Correctness Sabotages Art* (San Francisco: Encounter Books, 2004), 115–128. On Encounter Books, see *New York Times*, January 28, 2005, A17.

31. *HW*, January 17, 1863, and April 25, 1863. In *Defiance: Inviting a Shot* (Plate 6), the banjo player directs his eyes (and ours) to the defiant soldier, who stares toward the distant shots. Combined, their gazes tie foreground and background into a single story.

32. *HW*, November 1, 1873, and June 26, 1875. Homer's women and children repeatedly gaze out to sea. (Was that partly because Homer's own father had sailed to gold-rush California in 1849, when Winslow was thirteen?) Later, Homer's trip to Cullercoats on the northeast coast of England in 1881–1882 yielded numerous similar pictures of women watching the sea. See Tony Harrison, *Winslow Homer in England* (Ocean Park, ME: Hornby Editions, 2004).

33. *HW*, June 14, 1862, and January 7, 1865. On images of black women, see Kate Roberts Edenborg and Hazel Dicken-Garcia, "The Darlings Come Out to See the Volunteers: Depictions of Women in *Harper's Weekly* During the Civil War," in David B. Sachsman et al., eds., *Seeking a Voice: Images of Race and Gender in the 19th Century Press* (West Lafayette, IN: Purdue University Press, 2009), 209.

34. See Wood/Dalton, 83–107.

35. Hugh Honour, *The Image of the Black in Western Art*, vol. 4, part 1 (Cambridge, MA: Harvard University Press, 1989), 78–85.

36. The image of "Seated Liberty," with a Phrygian cap, appeared on the obverse side of half-dimes (1837–1873), dimes (1837–1891), quarters (1838–1891), half dollars (1839–1891), and silver dollars (1840–1873). It also made a brief appearance later on the twenty-cent piece (1875–1878).

37. "American liberty is original," Davis argued, and not ever to be confused with "the liberty of the freed slave." By the time Thomas Crawford's bronze sculpture was finally put in place in 1863, the figure wore a helmet instead of the emblematic cap. Robert L. Gale, *Thomas Crawford: American Sculptor* (Pittsburgh: University of Pittsburgh Press, 1964), 124. See also, David Hackett Fischer, *Liberty and Freedom* (New York: Oxford University Press, 2005), 299; and Vivien Green Fryd, *Art and Empire: The Politics of Ethnicity in the United States Capitol, 1815–1860* (New Haven: Yale University Press, 1992), 177–200.

38. The image was apparently produced by J. H. Bufford's lithography firm, where Homer had served his unhappy apprenticeship. Bernard F. Reilly, Jr., *American Political Prints, 1766–1876: A Catalogue of the Collections in the Library of Congress* (Boston: G. K. Hall & Co., 1991), 540.

39. In "1860–1870" (*HW*, January 8, 1870), Homer makes prominent use of a freedom cap, placing it beside Lincoln and the Emancipation Proclamation. To emphasize the ironies behind the end of Reconstruction, Homer also puts a Phrygian cap on the central figure in *Dressing for the Carnival* (1877) (Plate 7).

40. Garibaldi spent time at Staten Island, New York, between 1850 and 1853; his cottage there is still preserved as a memorial. I am indebted to Marilyn Richardson for this clothing insight.

41. For modern evidence on old rumors that Lincoln sought "the Italian George Washington" as a commander and that Garibaldi pushed the president to make war on slavery, see *The Manchester Guardian*, February 8, 2000, p. 16.

42. "The Andersonville Prison," *NYT*, November 26, 1865.

43. Wood, *Gulf Stream*; Wood/Dalton. I have also written about gourds; indeed, the fact that I am a gourd grower adds to my

fascination with this painting. Peter H. Wood, "The Calabash Estate: Gourds in African American Life and Thought," in *African Impact on the Material Culture of the Americas: Conference Proceedings* (Winston-Salem, NC: Old Salem, Inc., 1998).

44. Marla Burns and Barbara Rubin Hudson, *The Essential Gourd: Its Art and History in Northeastern Nigeria,* UCLA Monograph Series Number 28 (Los Angeles: UCLA Museum of Cultural History, 1986); and Charles B. Heiser, Jr., *The Gourd Book* (Norman: University of Oklahoma Press, 1979).

45. Adrienne Koch and William Peden, eds., *The Life and Selected Writings of Thomas Jefferson* (New York: Modern Library, 1944), 258. In Maryland, Nicholas Creswell observed in 1794 that on Sundays the African Americans "amuse themselves with Dancing to the Banjo. This musical instrument (if it may be so called) is made of a Gourd something in the imitation of a Guitar, with only four strings and played with the fingers in the same manner." Quoted in Edward D. C. Campbell, Jr., with Kym S. Rice, eds., *Before Freedom Came: African-American Life in the Antebellum South* (Richmond, VA: Museum of the Confederacy, 1991), 69. The distinctive plant with its expansive tendrils prompted black writer Zora Neale Hurston, raised in Florida, to entitle her first novel *Jonah's Gourd Vine* (1934).

46. H. B. Parks, "Follow the Drinking Gourd," in J. Frank Dobie, ed., *Follow de Drinkin' Gou'd,* Publications of the Texas Folk-Lore Society, no. 7 (Austin, TX: 1928), 81–84. Also see the excellent children's book by Jeanette Winter, *Follow the Drinking Gourd* (New York: Knopf, 1988).

47. Honour, *The Image of the Black,* vol. 4, part 1, 220–222.

48. Ralf Norrman and Jon Haarberg, *Nature and Language: A Semiotic Study of Cucurbits in Literature* (London: Routledge & Kegan Paul, 1980), Part 1: "Pregnant Gourds" and "Delirious Pumpkins": The Semiotic Matrix of Cucurbits.

49. I am grateful to Roberta Logan and Marilyn Richardson for encouraging this line of inquiry.

50. For a young painter developing skill with oils, there is an artistic challenge in seeing how much can be done with different

tones of one rather unassuming color. As Homer approached thirty, the precocious penman and engraver excelled at shading with cross-hatching and dark ink, but creating subtle paintings with muted colors presented fresh technical problems to solve. He proved to be a quick study, as can be seen in the brownish palate that dominates *Skirmish in the Wilderness* (1865), *The Veteran in a New Field* (1865), and *Prisoners from the Front* (1866). But here, where the brightest and clearest shade of brown is reserved for the woman's face, the varied hues may have deeper implications.

51. Verner Sollors, *Neither Black nor White yet Both: Thematic Explorations of Interracial Literature* (New York: Oxford University Press, 1997), 285–299. Eastman Johnson hints at this issue in *Negro Life at the South* (Plate 4), by showing three mulatto females of different ages. Though forbidden to marry a white, if any one of them bears a child fathered by their white owner, that daughter will look very much like the white intruder.

52. Sollors, *Neither Black*, 293–296.

53. For Willis's poem, see F. W. P. Greenwood and G. B. Emerson, *The Classical Reader* (Boston: Lincoln & Edmands, and Carter & Hendee, 1830), 336–339. Augusta S. Moore, a popular writer who published excerpts from the sermons of antislavery minister Henry Ward Beecher, also composed a piece about Hagar. Moore's "Hagar's Farewell" appeared in no. 33 of Phineas Garrett, *One Hundred Choice Selections* (Penn Publishing Co., n.d.).

54. For the plantation equivalent of such abusive behavior (complete with servants named Hagar), see Thavolia Glymph, *Out of the House of Bondage: The Transformation of the Plantation Household* (New York: Cambridge University Press, 2009). "Chapters 1 and 2 investigate the female face of slaveholding power as it was expressed through violence against enslaved women in the plantation household" (4).

55. Genesis 16:1–16 (see also 21:9–21). In art, Hagar is often portrayed in the wilderness with a broken or empty vessel, which may give added meaning to the empty basket and bucket hidden in shadow at the lower right in *Near Andersonville*.

56. Delores S. Williams, *Sisters in the Wilderness: The Challenge of Womanist God-Talk* (Maryknoll, NY: Orbis, 1993), 33. See also Renita J. Weems, "A Mistress, a Maid, and No Mercy (Hagar and Sarah)," in *Just a Sister Away: A Womanist Vision of Women's Relationships in the Bible* (San Diego, CA: LuraMedia, 1988), 1–21; Wilma Ann Bailey, "Black and Jewish Women Consider Hagar," *Encounter* (Winter 2002).

57. Susanne Scholz, "Gender, Class, and Androcentric Compliance in the Rapes of Enslaved Women in the Hebrew Bible," *Lectio Difficilior (European Electronic Journal for Feminist Exegisis)*, 1/2004. Toni Morrison invoked Hagar's name among the many biblical references in her 1997 novel *Song of Solomon.*

58. T. S. Eliot, "The Use of Poetry and the Use of Criticism" (1933), in Frank Kermode, ed., *Selected Prose of T. S. Eliot* (London: Faber, 1975), 87.

59. Vermeer's subtle link to the wider world is discussed suggestively in Timothy Brook, *Vermeer's Hat: The Seventeenth Century and the Dawn of the Global World* (New York: Bloomsbury Press, 2008). A fine introduction to Vermeer and his work is available online at: http://www.essentialvermeer.com/.

60. Karen Rosenberg, "A Humble Domestic Crosses the Sea," *NYT,* September 11, 2009. Rosenberg reminded readers "that every prop in Vermeer's interiors is loaded with meaning." The artist, she noted, is reaching down the social ladder to paint a figure often portrayed with crude innuendo. The fact that he is working against pervasive stereotypes "makes Vermeer's milkmaid," with her simple "gravity," seem "all the more remarkable. She isn't drunk, lazy, or easy." Instead, "The maid is a young woman of sturdy build and inscrutable disposition" whose features "express wistfulness and consternation."

61. Significantly, one early use of Homer's image on a cover, in color, occurred in 1984 with "Liberating Our Past: 400 Years of Southern History," a special issue of the quarterly, *Southern Exposure* 12, no. 6 (November/December 1984). The editors noted that the bland title, *At the Cabin Door,* seemed to "undercut the picture's

quiet power and shelter the nation's 'art lovers' from its dramatic implications." Their description is worth quoting: "The scene . . . is one of Homer's least familiar works, in part because white collectors and critics have never wanted to deal with its explicit subject matter. . . . Homer adopted the same radically different vantage point toward historical events that revisionist Southern scholars have rediscovered in recent decades. People long considered non-actors on the basis of race, sex, or class have been moved to the center of the picture."

62. Gail Collins, *When Everything Changed: The Amazing Journey of American Women from 1960 to the Present* (Boston: Little, Brown & Company, 2009), surveys the background for this sweeping transition.

63. Deborah Gray White, *Ar'n't I a Woman? Female Slaves in the Plantation South* (New York: Norton, 1985). For a retrospective discussion of this important book, see *Journal of African American History* 92 (Winter 2007). In 1981, Bantam Books had briefly used the same image on a paperback edition of *Uncle Tom's Cabin,* with an introduction by Alfred Kazin.

64. Nicholas Kristof and Sheryl WuDunn, in their recent book, *Half the Sky: Turning Oppression into Opportunity for Women Worldwide* (New York: Knopf, 2009), argue that the paramount moral challenge of the nineteenth century was ending the crime of slavery, and the comparable challenge for our twenty-first century involves changing the status of women around the world. Like the earlier abolitionists, whom they invoke, the authors spell out the dimensions of the problem and the potential moral and material rewards that change will bring to the entire globe. See especially pages xvii, 234–237.

65. Ann Jones, "Remember the Women?" *The Nation* (November 9, 2009): 22–26.

66. The Nigerian writer Wole Soyinka, Africa's first Nobel Laureate, states, "The European mind has yet to come into full cognition of the African world as an equal sector of a universal humanity . . . for if it had, it would have placed the failure of European humanism centuries earlier—at the inception of the Atlantic slave trade."

Quoted in A. Dirk Moses, "The Fate of Blacks and Jews: A Response to Jeffrey Herf," *Journal of Genocide Research* 10, no. 2 (June 2008).

67. Secular but profound, Homer had deep roots in New England and in the Protestant Reformation. More than we realize, he was a radical, steeped in tradition, who quietly embraced a viewpoint that had no regard for hierarchies. A searching recent exploration of this rare outlook from the 1830s to the 1860s is John Stauffer, *The Black Hearts of Men: Radical Abolitionists and the Transformation of Race* (Cambridge, MA: Harvard University Press, 2002).

ACKNOWLEDGMENTS

I spent a formative decade of my life in Cambridge, Massachu-
setts, living not far from where Winslow Homer grew up. Un-
like Homer, I had the opportunity to attend Harvard College
and to return to the university as a graduate student. While
there, I was fortunate to know Nathan Huggins, a gifted and
generous scholar. He encouraged interdisciplinary work and
urged a broad view of African-American history, stressing its
integral place in American culture. Before his untimely death,
he also taught and wrote about the ways that black history in-
tersects with American art, so I hope he would have been inter-
ested in this project.

I am grateful to Henry Louis Gates, Jr., for inviting me to give
the 2009 Nathan I. Huggins Lectures, which have led to this
book. Professor Gates and his colleagues at the W. E. B. Du Bois
Institute made my return to Cambridge most enjoyable. It was
a delight to see old friends, and I am indebted to all those who
found time to attend my talks. Many people sharpened my
thinking with their thoughtful questions and comments—
especially Roberta Logan, Marilyn Richardson, and Patricia
Hills. Thanks also go to Joyce Seltzer and others at the Harvard
University Press for their interest, encouragement, and editorial
skill.

I appreciate the kindness of the Newark Museum, which
celebrated its one-hundredth anniversary in 2009. The fine
staff gave me a chance to explore the museum's files regarding
Near Andersonville. This, in turn, introduced me to the impres-
sive family that had donated the painting. An undergraduate

paper, written by a young family member at the time of the picture's rediscovery, specially sparked my interest. I contacted its author, Terry Corbin (Horace Kellogg Corbin III), and he was kind enough to share his recollections and knowledge. As college students in the 1960s, both of us had already been drawn to American art in general, and to Winslow Homer in particular.

In North Carolina, friends and colleagues have offered encouragement. The Duke University Library and Duke's Nasher Museum of Art have been invaluable. At the University of North Carolina in Chapel Hill, the rich Southern Historical Collection yielded just the documents I needed in learning more about Sarah Louise Kellogg. In Hillsborough, Ayr Mount and the Saratoga Grill have provided regular highlights to my working week. At home, Lil Fenn continues to shorten my sentences and expand my life. She has encouraged my research, discussed my ideas, and tolerated my technology deficit. Without her friendship, love, and counsel, this project could not have happened.

I dedicate this book, with deep affection, to three important friends. I only regret that nowadays they each live so far away. Julius Scott is an exceptional historian who remains, with Lil, a founding member of the Dragging Canoe Society; I cherish his wisdom and wry humor. Karen Dalton, with her grace and high standards, has taught all of us a great deal about black images in Western art; she shares my love of Homer, and she is a generous and knowledgeable helper of others, including me. Brooke Hopkins has been a friend since the eighth grade; he towered over me then, and he still does. Not too long ago, Brooke and I visited Andersonville together; we ate shrimp and grits with his Aunt Dottie in Valdosta, and we explored South Caroli-

na's Sea Islands from St. Helena to McClellanville. Like the woman in Homer's painting, each of these unique spirits has experienced more sides of life than most of us. All three, in different ways, have lived "near Andersonville." I am grateful for their friendship.

INDEX

Page numbers in **boldface** indicate figures.